MADELEY

THROUGH TIME

Tony Lancaster

AMBERLEY PUBLISHING

First published 2012

Amberley Publishing
The Hill, Stroud
Gloucestershire, GL5 4EP

www.amberley-books.com

Copyright © Tony Lancaster, 2012

The right of Tony Lancaster to be identified as the
Author of this work has been asserted in accordance
with the Copyrights, Designs and Patents Act 1988.

ISBN 978 1 4456 0387 2

British Library Cataloguing in Publication Data.
A catalogue record for this book is available from
the British Library.

Typeset in 9.5pt on 12pt Celeste.
Typesetting by Amberley Publishing.
Printed in the UK.

Introduction

The parish of Madeley lies in the north-west corner of Staffordshire. Crossing one of its boundaries at Onneley takes you into Shropshire, and it is only a short journey to the west of the parish before you are in Cheshire. It is important historically that Madeley has been within easy reach of three market towns – Market Drayton (Shropshire), Nantwich (Cheshire) and Newcastle under Lyme (Staffordshire). With the advent of industrial development in the northern parts of the parish from the nineteenth century, the close proximity of the Potteries was equally important for Madeley.

The present appearance of the parish is both revealing and deceptive in terms of its historical past. It is revealing in the continued existence of some impressive early buildings and features, even though they are now surrounded by later development. However, the predominantly rural appearance of the parish is deceptive, especially in the northern parts, Madeley Heath and Leycett. Here, the industrial past of the area can only be revealed on the ground by careful detective work.

Writing in 1970, the historian J. Kennedy considered that 'the heart of the main Madeley village itself, dominated by its ancient sandstone church, has hardly changed in essential aspect, since the Middle Ages'. If other features like Madeley Pool and the Old Hall are included, this area of the parish suggests a past that in fact began to be recorded in a royal charter of AD 975 and later an entry in the Domesday Survey of 1086. As well as the church there was an impressive manor house. This was established by the first of the landowners of Madeley, the de Stafford family. It was much altered and expanded by the Offleys, who became Lords of the Manor in the sixteenth century. In the same area of the parish, along Manor Road, was the site of Madeley Great Park, one of three deer parks in the parish. Only earthworks and a place name – Baldwins Gate – remain of the park. But the Old Hall (largely unchanged) and Town House are still there to suggest prosperous farming in the sixteenth/seventeenth centuries.

The Offleys left their mark on the village, building the almshouses and a school as well as rebuilding the manor house. Thomas Offley (1505–82) was a wealthy cloth merchant in London, where he became Lord Mayor in 1556. In 1547 he had purchased the Madeley estate, and the Offleys remained Lords of the Manor for five generations. In 1679, however, the Offleys joined forces with the Crewe family through the marriage of the third John Offley with Anne Crewe. By the early nineteenth century, the Offley part of the name was dropped and the village squires were now the Crewes, whose crest began to appear on estate houses. A second manor was built in Middle Madeley in about 1820, though the family's main residence was Crewe Hall. Charles Hungerford Crewe (1812–94) emerged as a potent force in the parish. He was one of a breed of improving landlords, who oversaw a great deal of rebuilding in the parish. The church, the school, a new vicarage, three mission churches, miners' cottages in Leycett – all these are part of a long list of buildings that benefited from Hungerford Crewe's attention.

Until the nineteenth century, the chief occupation in the parish was agriculture and its associated trades. There was some small-scale industry – coal and iron ore deposits in the northern part of the parish, Madeley Heath and Leycett, were beginning to be exploited. There is still a Furnace Lane in Madeley and there is evidence of iron smelting in that part of the parish, making use of water power provided by the River Lea. However, it was the nineteenth century that saw major changes: 'the parish of Madeley was now entering the industrial age on a much bigger scale than before' (J. Kennedy, p. 49). Coal and iron were the basic requirements of the developing industrial changes of the period and Madeley had both. Roads had begun to improve in the eighteenth century, with two turnpike roads crossing the parish: Newcastle to Audlem and onto Whitchurch and Newcastle to Nantwich. But it was rail transport that was the key to industrial development in the parish. The main line Grand Junction Railway came in 1837 and a station was built at Madeley. The coal mine at Leycett was then linked by a mineral line to sidings at Madeley. Leycett had its station on the North Staffordshire Railway's 'Audley' line. This provided links with the Stoke–Crewe line and, via Keele Junction, with the Newcastle–Market Drayton line. Locally, the coal from the Leycett pit was transported to the wharf at Madeley Heath to fuel substantial brick and tile works. The rail links also enabled the coal to be transported to the Potteries and further afield to other industrial centres. Leycett itself was 'a whole new, planned mining village built in the mid-nineteenth century' (J. Kennedy, p.56) on land leased out by the Crewe estate. It became a

close-knit community, which provided wealth for its owners and jobs for a large number of men. Also, like all pit villages, it had its share of mining tragedies.

With the development of industry came a rapid rise in population. In 1801 the population was 945, in 1851 it had reached 1,655 and by the turn of the century there was a population of 2,909. A century later, in 2001 population was 4,044. The parish saw considerable changes in the twentieth century. The Crewe estate was sold, with most of the land going to its tenants. Mining at Leycett closed down and the village practically disappeared. Clay tile making continues at one site. As elsewhere, the motor vehicle has become the dominant form of transport and the M6 runs through the parish. Three quarters of the residents of Madeley travel to work by car in 2011. The two railway stations disappeared, though trains still speed along the mainline tracks. A College of Education was built in 1961, only to be the victim of 'cuts' some twenty years later. Considerable amounts of housing have altered the appearance of several parts of the parish. However, there is also continuity as well as change. Farming has remained an enduring presence. There is a continuing sense of community, expressed in a newly opened village centre.

The Organisation of the Book

This book takes the reader on a visual journey through the parish and attempts to illustrate both continuity and change. The journey starts from the south along Manor Road. It twists and turns, first along Bar Hill to Onneley and then returns to enter the village of Madeley, just south of the church. The main road from Woore is followed through the component parts of the village: Great Madeley, Middle and Little Madeley to Madeley Heath. Here the road meets the main Newcastle-under-Lyme to Nantwich Road. After exploring this area, the journey goes on its last lap to Leycett. Along the way, there are stops to explore the varied social, economic, educational, religious and cultural life of the parish. Much of the past is reflected in the buildings of the parish. At the same time, much has disappeared, especially of the industrial past of Madeley. But, although the industrial remains are less visible, it remains important to try and recreate that part of Madeley's history on this journey.

Madeley Manor

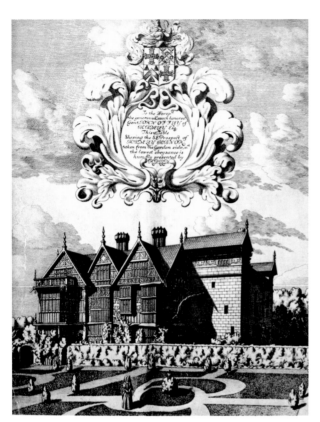

Entering Madeley parish along Manor Road, the traveller passes, on one side of the road, the site of the original Madeley Manor. This engraving of Madeley Manor is taken from Dr Plot's *Natural History of Staffordshire* (1686). An earlier building belonging to the Stafford family was transformed by the Offley family into the impressive Tudor-Jacobean mansion shown here. The Offleys purchased the Madeley estate in 1547 and for five generations were lords of the manor. The house was set in an attractive landscape, part of the medieval deer park, known as Madeley Great Park. It was later abandoned and fell into ruin. Some recognisable features, such as the arch shown in the 1960s photograph, remained into recent times. Now there is little to show that this was the site of such an impressive house.

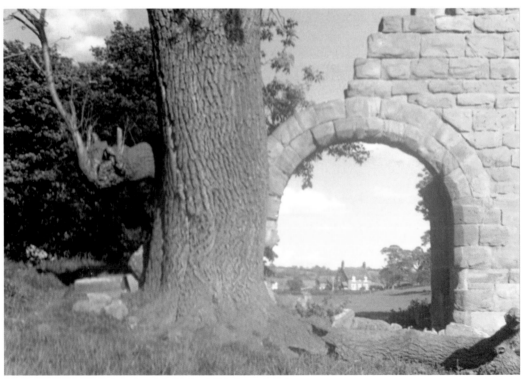

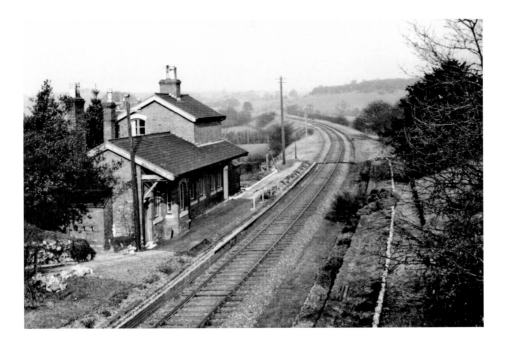

Madeley Road Station

On the other side of Manor Road, in complete contrast, is a reminder of a much later period in Madeley's development – the railway era of the nineteenth century. This was Madeley Road Station, on the Newcastle to Market Drayton line, built by the North Staffordshire Railway and opened in 1870. Two miles from the village centre, it was used mainly for the transport of milk from the local farms: 'a purpose built slide was used to convey full (17 gallons) churns to the platform from the road bridge above' (C. R. Lester). It closed in 1931 but the combined living quarters shown in the old photograph continued in use, being finally demolished in 1979.

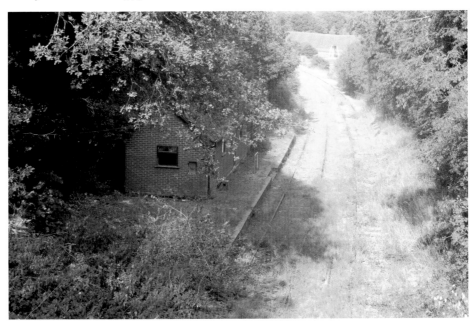

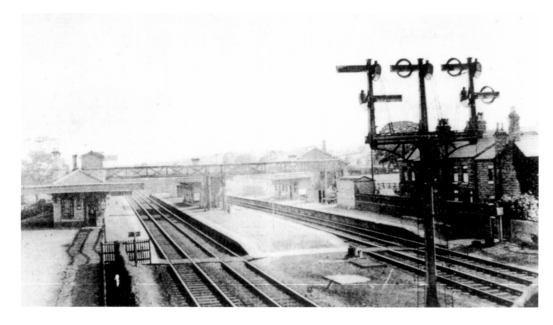

Madeley Station

Now part of the West Coast Main Line, this line started life as part of the Grand Junction Railway in 1837 (later the LNWR in 1846) and crossed the parish of Madeley. Built in 837, Madeley Station and became of great importance to the developing industries in the parish, especially the coal mining in Leycett. It was a substantial station, with four platforms. The station was closed to passengers in 1952 and later demolished. As the recent picture shows, all traces of the sidings, goods yard and signal box have also gone. The skyline is now dominated by the overhead structures needed for the electrification of the line, which was begun in 1963.

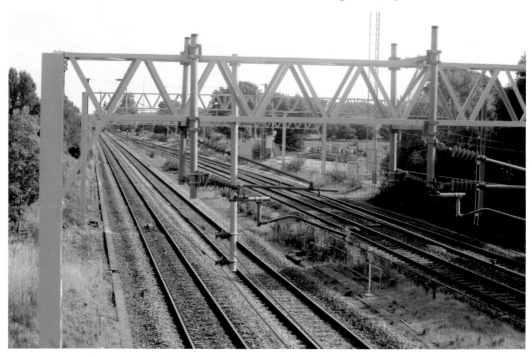

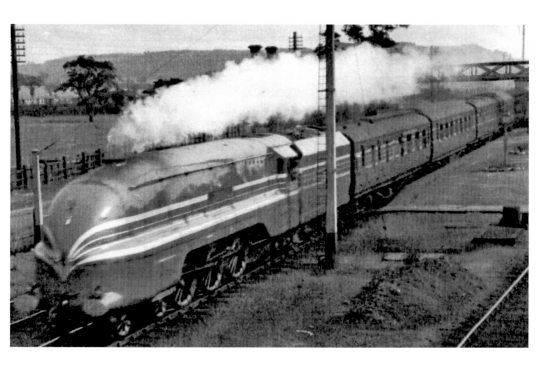

A Fast Stretch of Track

The Coronation Scot is shown in the old photograph, passing through Madeley in 1939. On 29 June 1937 it set a speed record of 114 mph along the stretch of track from the Whitmore summit which passes through Madeley to Crewe. The line is currently used by Virgin inter-city trains of the type shown here.

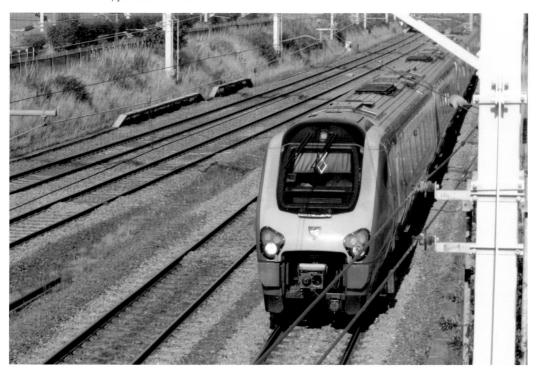

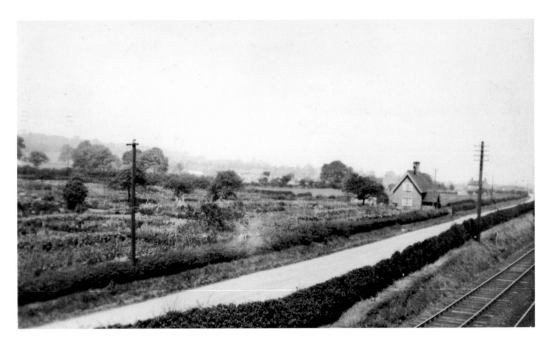

A Forgotten Monument

Just past the surviving railway bridge is Monument Lodge, shown in the old photograph. Behind the lodge, tucked away out of sight, is a further reminder of the Offley name in Manor Road. At the back of the allotments stands a memorial to Mrs Cunliffe-Offley, a sister of the second Lord Crewe. She lived in the manor built in the 1820s and died in 1850. She is commemorated by a 'Gothic-style drinking fountain and allotment gardens' (J. Kennedy, p. 71). The fountain survives, in a rather dilapidated state, amid the still flourishing allotments.

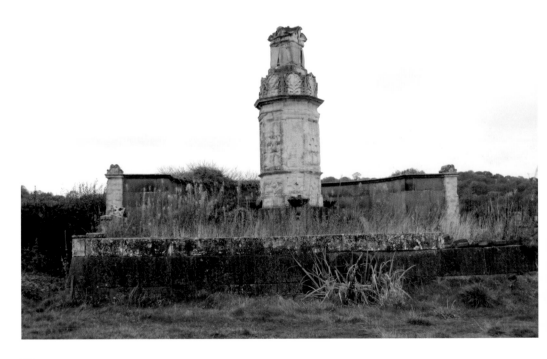

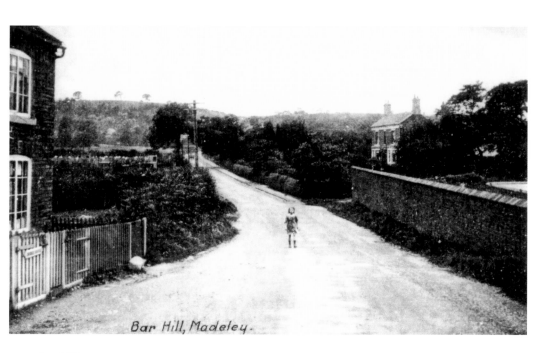

Bar Hill, Madeley.

Bar Hill

The young girl stands at the bottom of Bar Hill, just beyond the railway bridge over the main line. This is where Manor Road joins the old turnpike road. Just visible over the wall to the right is a reservoir, formerly used by the steam trains on the adjacent railway. Behind that wall, the land has now been drained and built over by houses. The house to the left remains, with some additions, as does the one on the right, though now hidden by trees.

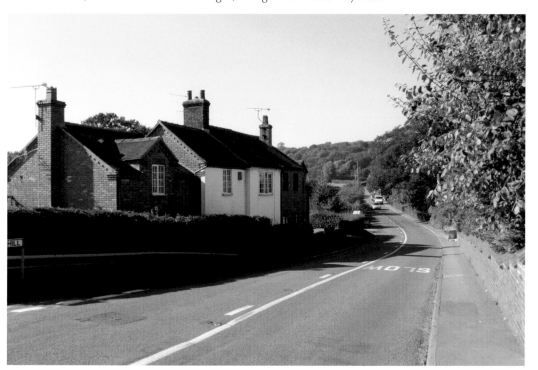

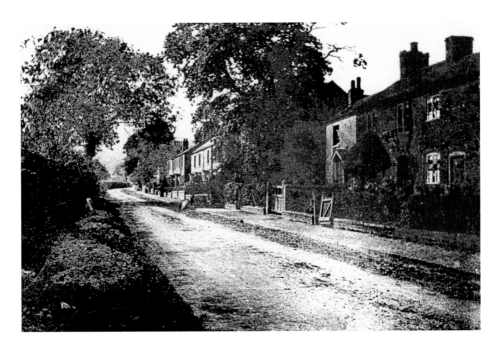

A View Along Bar Hill I

The name of Bar Hill refers to the toll-bar on this stretch of the turnpike road that leads to Onneley. There, the road crosses the parish boundary into Shropshire. The houses on the right were probably late nineteenth century. They are pictured here in 1904 and remain today. But, as the modern picture shows, the motor car dominates the scene. The left-hand side of Bar Hill on this stretch of road keeps its rural appearance.

A View Along Bar Hill II

Another view of Bar Hill, looking down the hill, and this was probably taken a few years after the previous photograph. The wall has gone but fields remain on the right. The big difference between the two pictures is the presence of the children, posing across the road. Their chances of survival now, on a fast stretch of road, would be remote!

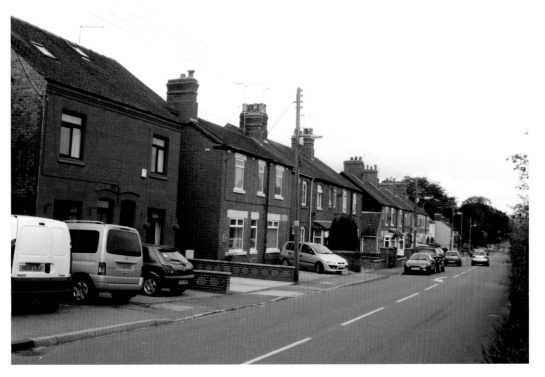

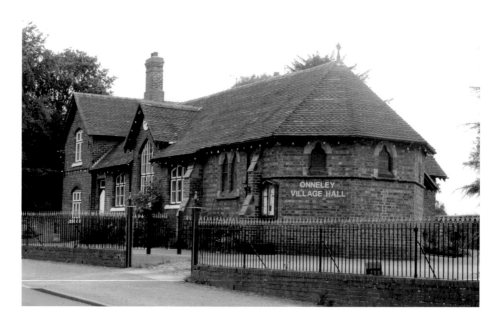

Onneley

From a cutting at the top of Bar Hill, the road descends to Onneley on the edge of the parish. The village hall started life as a combined Mission church and school in the 1870s. It was one of three such buildings in the parish, built with the support of an active lord of the manor, Hungerford Crewe. There is an attached house on the left, originally for the school teacher. The church was dedicated to St Chad, whose cross can be identified in the brickwork of the exterior, and at the east end of the roof. The ecclesiastical appearance is underlined inside the hall, with an altar still in the chancel area. The very well-kept hall is used for many village functions. It remained as a school until the 1960s.

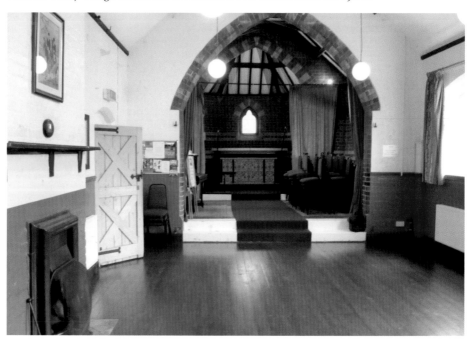

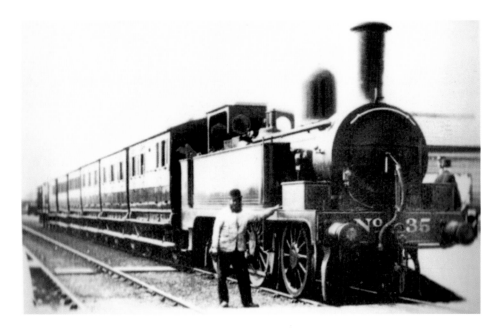

Station Road, Onneley

If you searched for a station along this winding country lane, you would be disappointed. The name was given in the hope of a station between Madeley Road and Pipe Gate on the Newcastle–Market Drayton line. However, it was 'inevitable' that the request, in 1917, for a station was turned down at a time when 'the 1914-18 War led to a reduction in passenger services' (C. R. Lester). The recent picture shows the railway embankment, across the fields from the end of Station Road. The earlier one is of one of the long-serving locomotives on the line. NSR Class 'A' 2-4-OT, No. 35) stands at Pipe Gate Station, not far down the line towards Market Drayton.

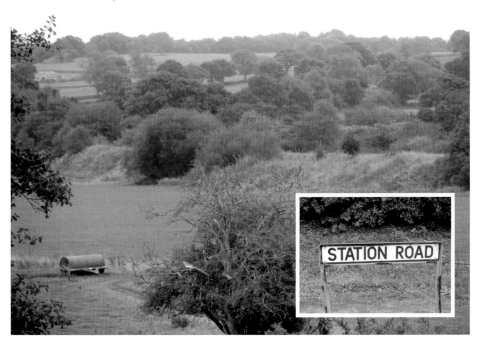

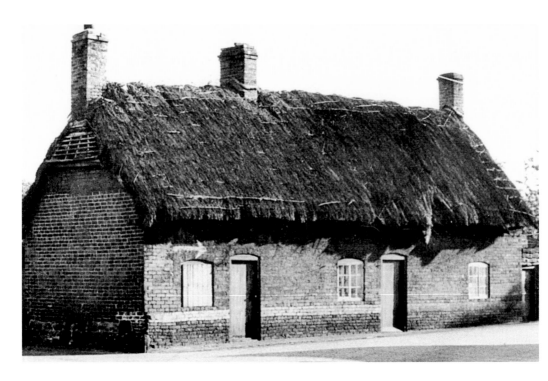

Station Road, Madeley

Returning to Madeley and crossing the railway bridge, there is a right-hand turning into Station Road. This was the road into the village before the railway came. On the corner was a thatched cottage, used by the vicar of Madeley when the original vicarage next to the church was destroyed – probably by fire. The cottage was later replaced and the corner by the railway bridge has been developed.

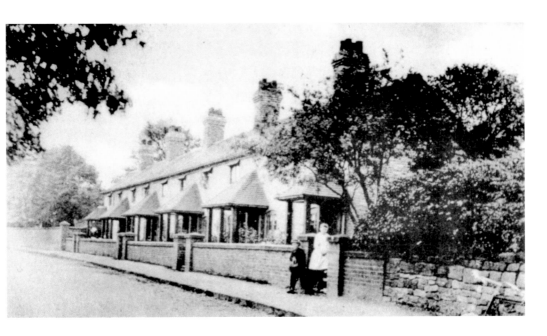

The Almshouses

'Almshouses, SW of the Church. 1645. Of that date, the brickwork; the porches are Victorian' (N. Pevsner, p. 200). The almshouses were built with money left by Sir John Offley in his will of 1645, which stated that 'ten almshouses should be built and endowed with an income of £45 per year' (J. Kennedy, pp. 28–29) They were renovated later by the 'improving' Victorian landlord of the Crewe estate, Hungerford Crewe. The outward appearance of the almshouses has changed little.

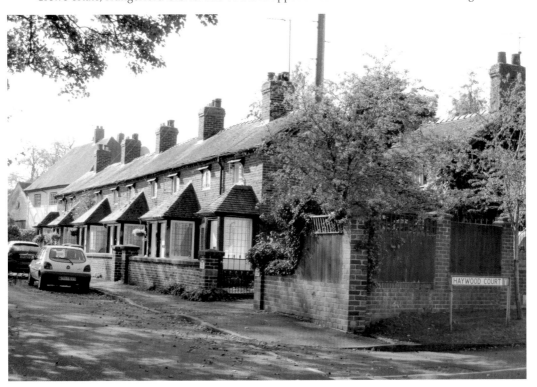

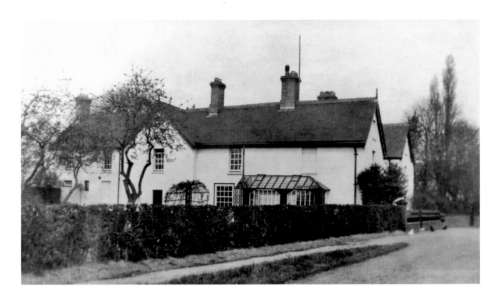

Town House, Station Road

Though much altered over the centuries, Town House remains an 'impressive' example of 'a number of substantial farm houses dating from the sixteenth and seventeenth centuries' (J. Kennedy, p. 37). Later, Town House was used to provide a stopping place for coaches, with overnight accommodation for their passengers. The owner of the house in the early nineteenth century, Weston Yonge – described as 'a man of considerable fortune' (Osborne's Railway Guide, 1838) – lost an expensive lawsuit against the Grand Junction Railway for 'spoiling his grounds'. More recently, it became the house and surgery of the local doctor. It is now a private residence.

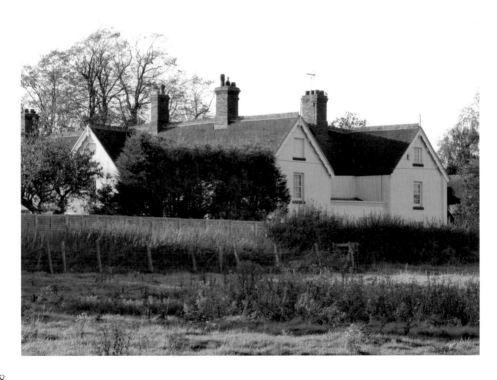

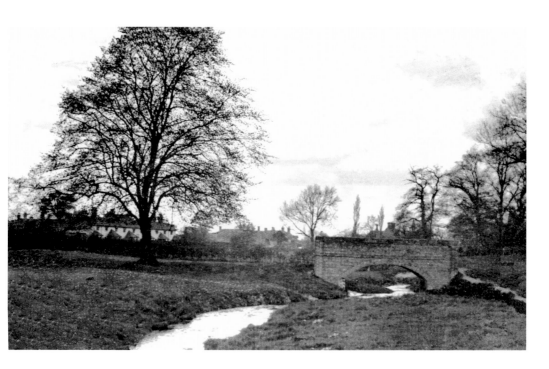

Bridge Over River Lea

On the opposite side of Station Road, the River Lea runs through these peaceful meadows towards the parish church. Behind the trees in the background, the road runs past the church and a row of cottages. Because this road is often flooded, an alternative route went across the meadow via the bridge in the old picture. The bridge, situated between the bushes in the centre of the modern photograph, has since disappeared. On the left of the old picture the almshouses stand out clearly. In the new picture they are just visible to the right of the white house.

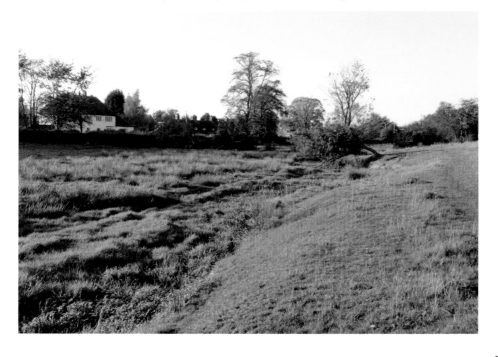

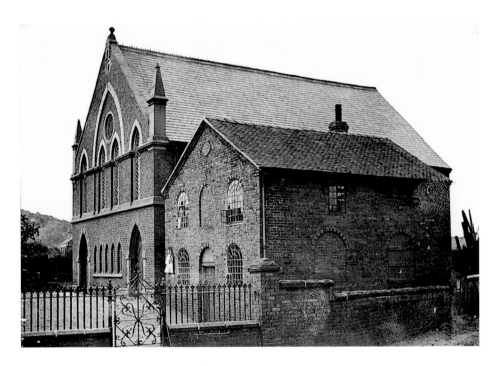

The Methodist Chapel, Moss Lane

The nineteenth century saw the arrival of Methodism in Madeley, in both the Wesleyan and Primitive forms. This old photograph shows a Wesleyan chapel situated right by the mainline railway bridge. The smaller building, the original chapel of 1831, still stands and is now a private residence. It became the Sunday School when the larger chapel was built. That building, however, became unsafe because of the vibrations caused by passing trains and was demolished in 1935.

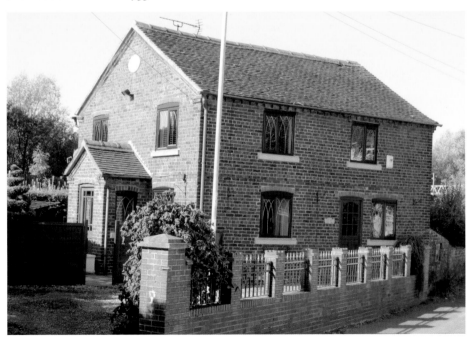

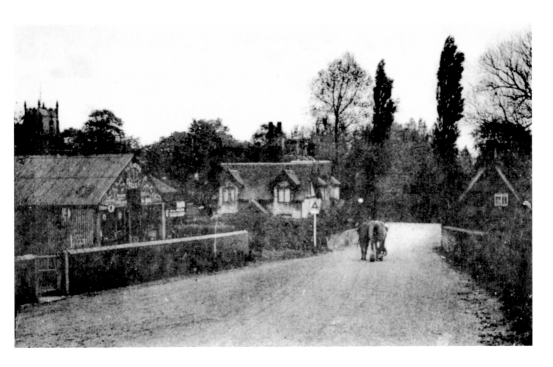

Smithy Corner

This area, with its present pleasant residential appearance, was formerly a busy site. In the centre of the old picture is the Empire Cycle shop in the early part of the twentieth century. The building to the right is Smithy Cottage, behind which was the village smithy.

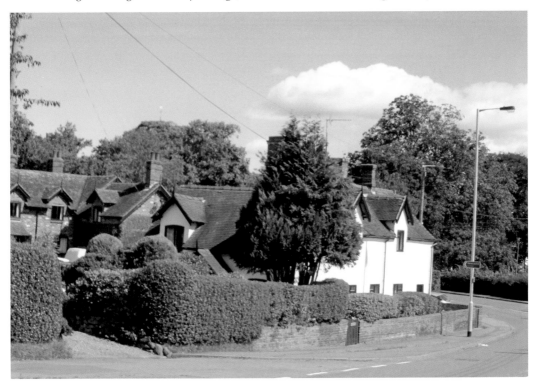

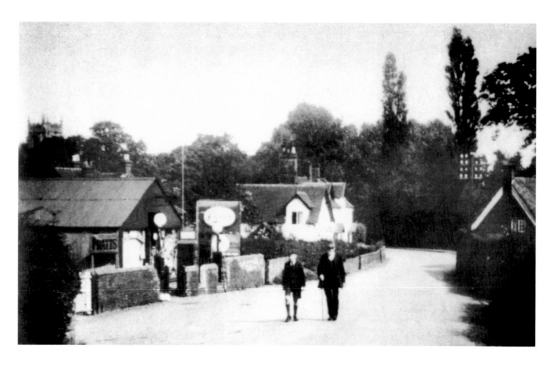

The Era of the Motor Car

By the 1930s, as the old picture shows, the era of the motor car had begun. The cycle business continued and became Catell's Motor & Cycle Depot. But, it is the petrol pump that is the symbol of this new era. So, this view down to the smithy provides a neat summary of changing methods of transport in the first half of the twentieth century: the horse, the bicycle and the motor car.

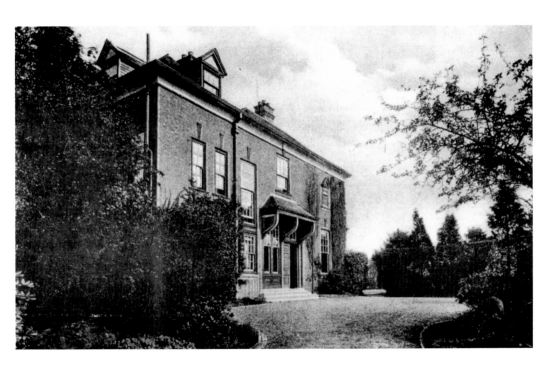

The Old Vicarage

The outward appearance of the Old Vicarage (1882) is little changed. It was built after the destruction of the previous vicarage. The building displays the Crewe coat of arms (on the far side here) in recognition of the patron of the church at that time, Hungerford Crewe. His 'hand is evident' in much of the building and rebuilding in Madeley in the 1870s and 1880s (J. Kennedy, p. 72). It is a large building and had forty rooms. It is now a private residence.

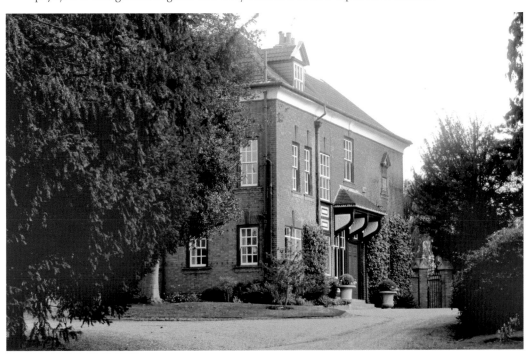

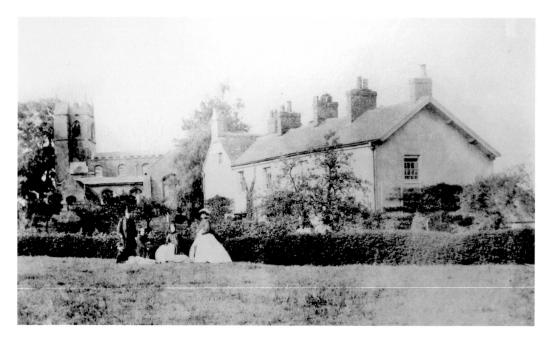

An Older Vicarage – and the New One

The older photograph shows the Madeley vicarage that existed before the building of 1882. It stood next to the site of the modern car park. The inscription on the picture reads as follows: 'The Rev. T. W. Daltry and Mrs Daltry with friends. The Old Vicarage, pulled down about 1883 AD'. The Revd T. W. Daltry had succeeded his father, J. W. Daltry, in 1880. They provided a remarkable family dynasty: father and son as vicars of Madeley for seventy-one years from 1833 to 1904. What a difference there is with the present-day vicarage!

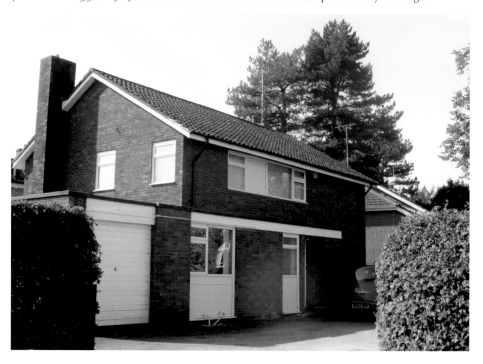

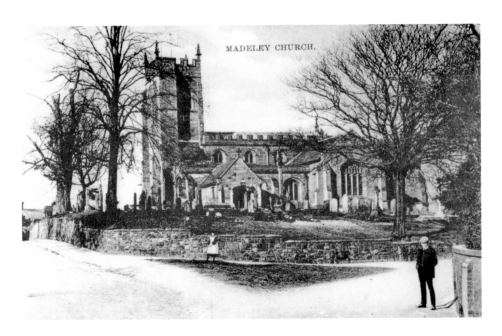

All Saints Church I

This is the parish church, probably of around 1910. All Saints is an attractive building of red sandstone, dating back to the twelfth century. In the fifteenth century, much rebuilding meant that its main character is 'still to-day that of a handsome late medieval "perpendicular" church' (J. Kennedy, p. 20). The modern picture illustrates only minor changes in the last hundred years.

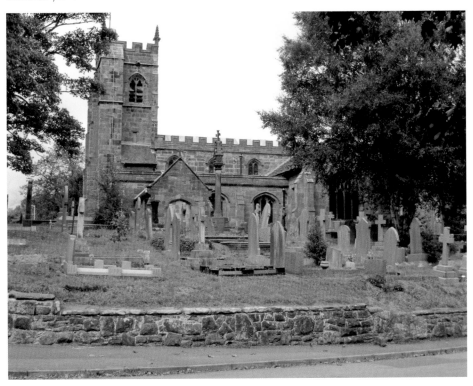

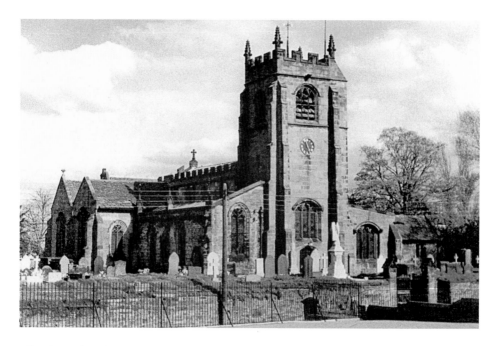

All Saints Church II

This view of the tower and west end of the church was taken in the 1950s. The picture below illustrates just one of the striking stained glass windows in the church. The window shown here commemorates the friendship between the second John Offley and Isaac Walton. They often fished together in Madeley and the famous angler dedicated his *Compleat Angler* (1653) to Sir John. The bottom corners of the window depict Madeley Church (left) and the old manor (right). Another window commemorates the first John Offley as Mayor of London. An attractive window from William Morris's studio is a reminder that the church was restored in 1870–72.

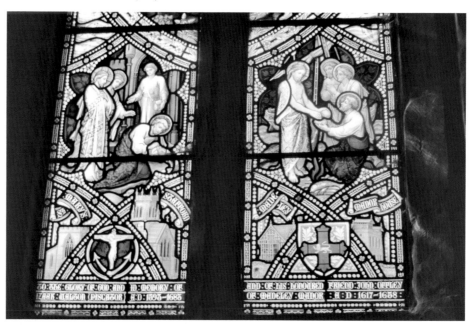

Charles Hungerford Crewe (1812–94)

Here is Charles Hungerford Crewe, the third Lord Crewe, with his niece and great nieces. He has been described as 'a bachelor and a very eccentric man' (J. Kennedy, p. 71) but also as a model landowner. He never resided in Madeley but he took an active interest in his estate properties there. The Crewe crest still appears on a number of buildings in the parish. Now, standing before the chancel, an inscription marks the role he played in the restoration of the church. The major change was the rebuilding of the chancel in 1870–72.

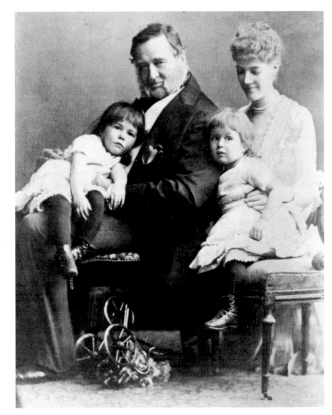

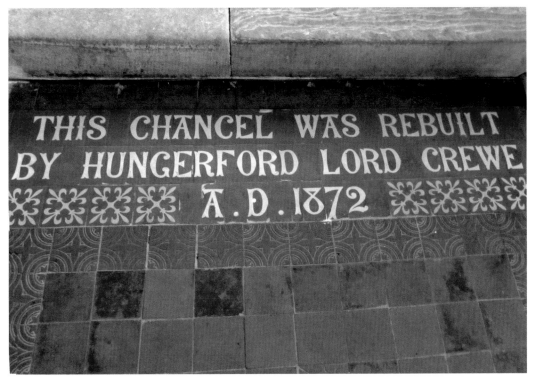

THIS CHANCEL WAS REBUILT BY HUNGERFORD LORD CREWE A.D. 1872

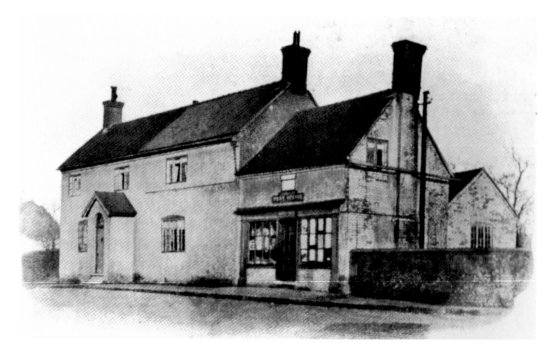

Post Office Corner

Just beyond the church was the main Madeley post office, standing on the corner of Castle Lane and the Holborn. The post office, which was also a grocery shop, closed in 1984. It is now a private residence. The outlines of the old building remain the same, in spite of its modernisation. This corner is at the entrance to the Holborn, the old road into Madeley village.

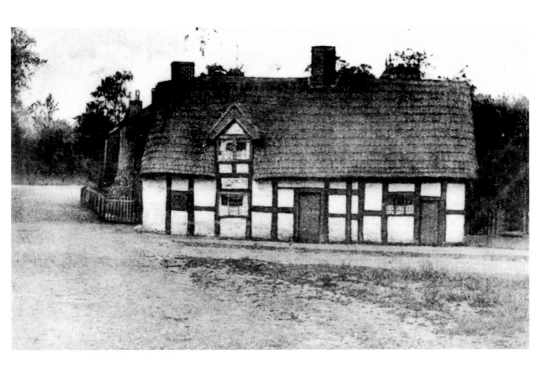

Opposite Post Office Corner

The black-and-white houses that currently occupy this site were built in the early twentieth century. They replaced the two thatched cottages in the older picture.

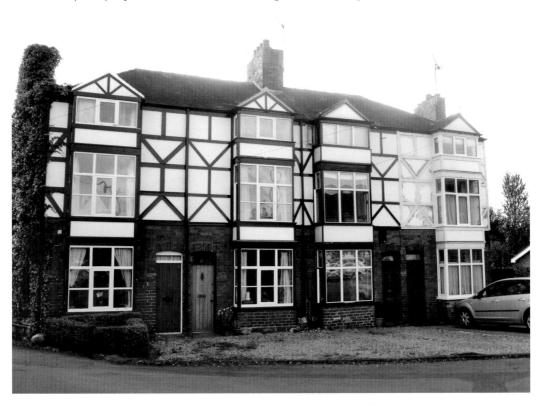

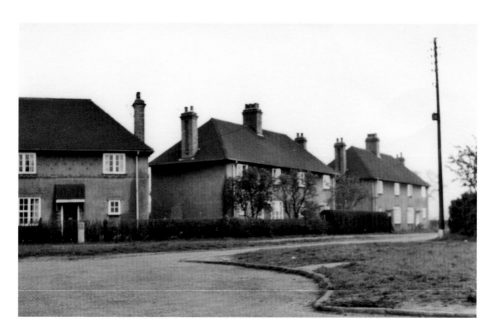

The Knightley Estate

Continuing along Castle Lane, the journey takes you to a small housing development, built after the First World War. With improvements in public transport, there was an extension of housing in the parish. These houses are 'a small but interesting example of an early local government planned estate, dating from 1921' (J. Kennedy, p. 79). According to local memory, the rents were not cheap at 9/- a week, but they were the first houses in Madeley to have electricity in 1927 (*Madeley in Living Memory*, pp. 18–19).

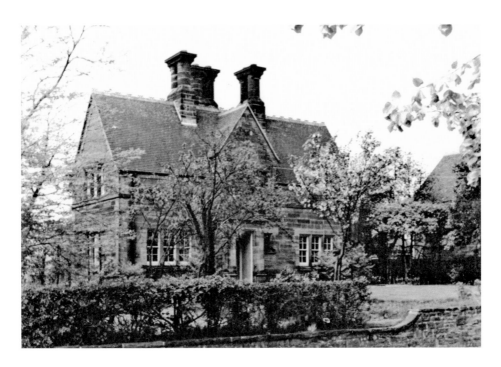

The Schoolhouse

The schoolhouse is another reminder of the construction that went on in the 1870s during the active management of the Crewe estate by Hungerford Crewe. This house, now a private residence, was built for the head teacher of the school next to it. The appearance of the frontage of the house, like that of the school, remains remarkably unchanged.

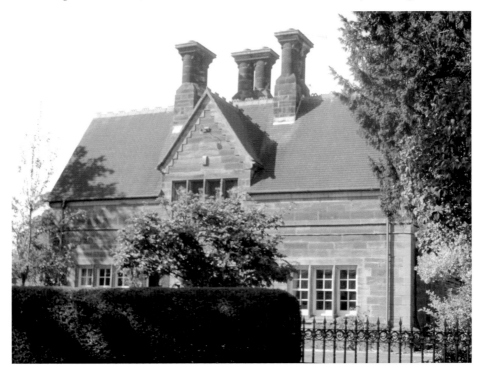

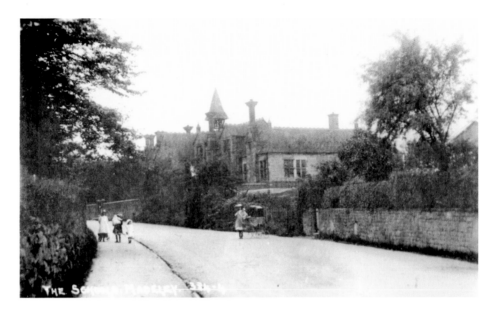

The Sir John Offley Primary School

The original school was endowed by Sir John Offley in the seventeenth century, as its name suggests. The present building, however, owes its appearance to Hungerford Crewe, as its Victorian aspect shows. According to Pevsner (p. 200), it was rebuilt in 1875 and enlarged in 1887. The frontage remains little altered, with the newer extensions and sports areas of the school stretching some way to the rear. A new road, called Isaac Walton Road, now makes a turning just before the school. It provides a safer entrance and exit for the children than the old one on the main road.

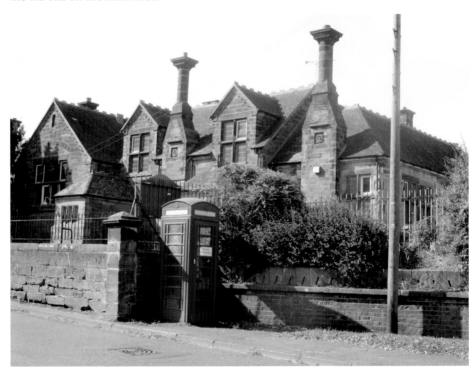

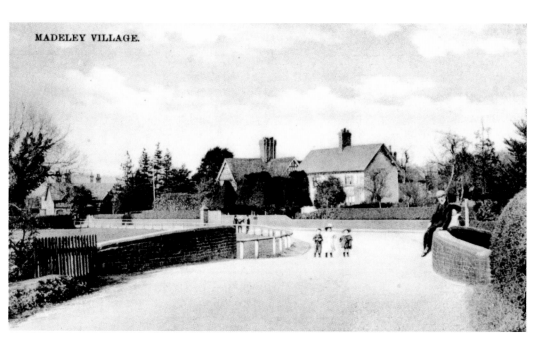

Towards the Village Centre

Approaching the village, past the church and school, this is a view taken early in the twentieth century. The bridge where the old man sits crosses the River Lea. In the background is Yew Tree House, formerly the Crewe Estate manager's house. Next to it is the Old Hall. The corner on the left beyond the bridge is the open grassy area. As the modern picture shows, very little has changed at this corner.

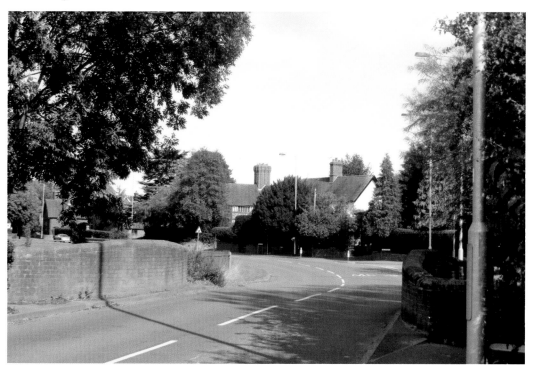

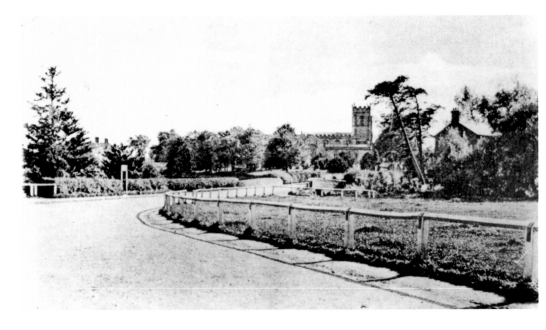

View Back Towards the Church

These pictures show the reverse of the previous illustrations. The early picture looks back towards the church, which is plainly visible. The area to the right is still an open green. Here cattle were once grazed and sometimes funfairs set up (*Madeley in Living Memory*, p. 16). The area near the bridge, known as 'the Springs', often flooded. The view has not changed radically, but the church has largely disappeared from view, behind the trees.

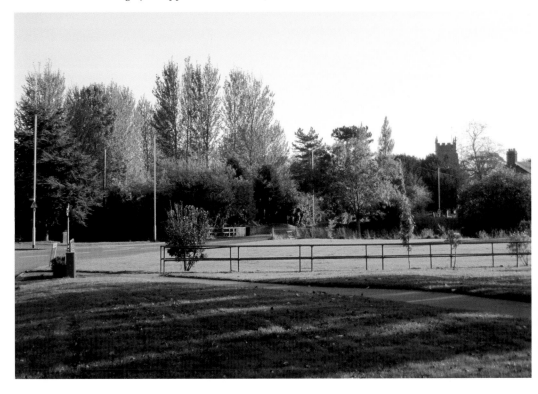

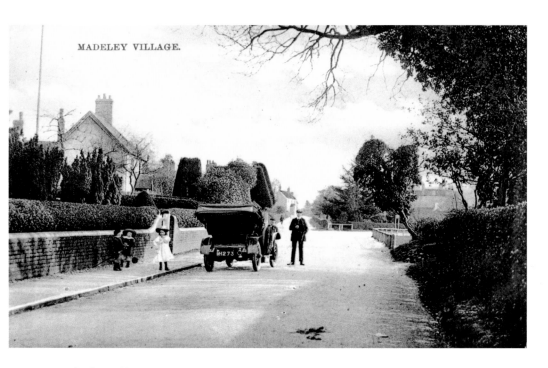

MADELEY VILLAGE.

Towards the Holborn

A similar viewpoint shows the emergence of the Holborn onto the main road, with the green to the right. The car suggests an early period in the motoring era. The Holborn would have been the route into the village centre in earlier days. The old police house – now a private residence – and the Madeley Poor House were both situated along the Holborn.

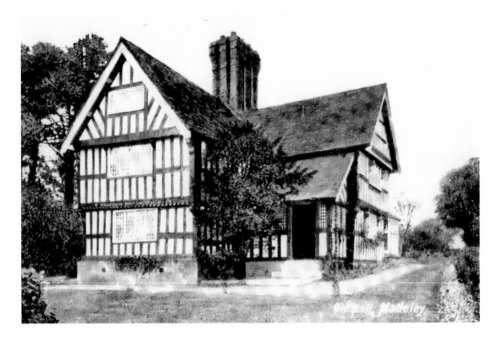

The Old Hall (1647)

This striking timber building proclaims its date and the words 'Walk Knave What Lookest At' on its exterior beam. However, 'despite its current name and its mocking inscription, it was a farmhouse and not the manor' (D. M. Palliser, p. 98). The sixteenth and seventeenth centuries were a period of considerable building in rural England, of which the Hall is an excellent example. Fortunately, as the modern picture shows, the building has been well preserved. The only outward change is a discreet notice, offering bed and breakfast.

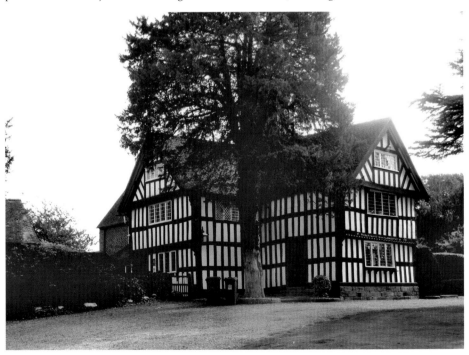

Trantom's
This house was formerly Trantom's shop, which, according to local memory, 'sold everything' including shoes and knitting wool (*Madeley in Living Memory*, p. 160). Trantom's also had a bakery and shop in Madeley Heath, from where supplies were brought. It is now a private residence.

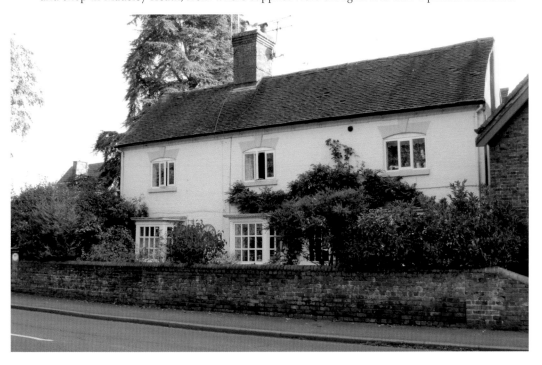

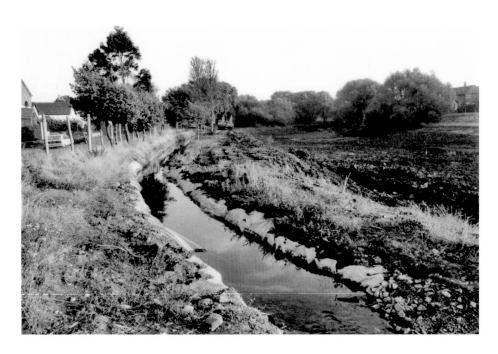

Madeley Pool

At the centre of Great Madeley is one of its most attractive features – Madeley Pool. It is difficult to imagine that plans were put forward in the 1960s to fill in the Pool and build houses over the area. The Pool had begun to silt up badly by this time. However, Newcastle Borough Council purchased the Pool and in the 1990s it was dredged, as the older photograph shows. A separate channel was built for the River Lea to help control silt deposit. The Pool now provides a home for wildlife and a place to stroll or just sit and relax.

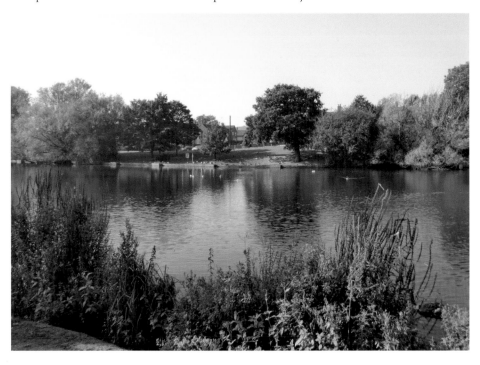

The View from Poolside

The view across the Pool from Poolside has changed considerably. The older picture, probably taken around 1930, shows the area known as the Moss, with open countryside stretching across towards to Bar Hill. After 1945, a large housing development – the Moss estate – was built and it would now be impossible to recapture the view in the older picture.

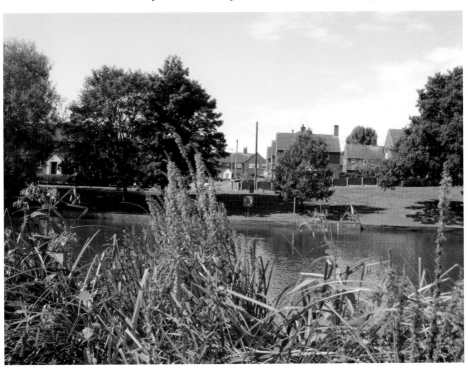

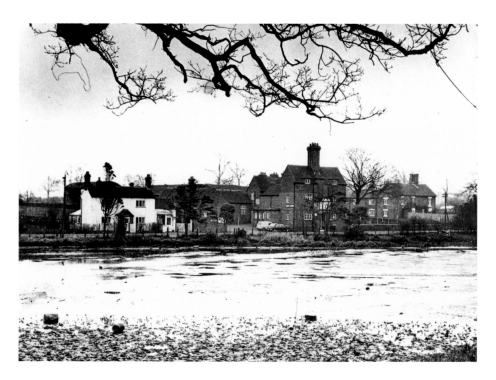

Poolside from the Moss

The older photograph shows Poolside from Moss Lane on the other side of the Pool. The Offley Arms – an eighteenth-century building – is clearly depicted, along with the houses on either side. Trees now obscure some of this view but it remains largely unchanged.

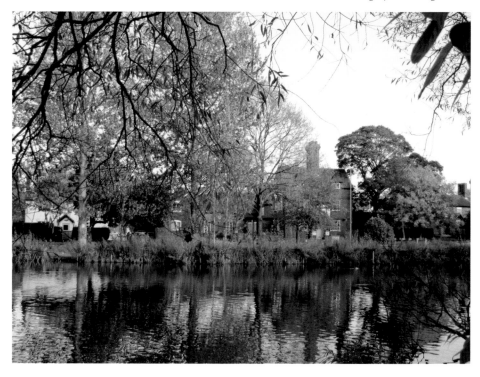

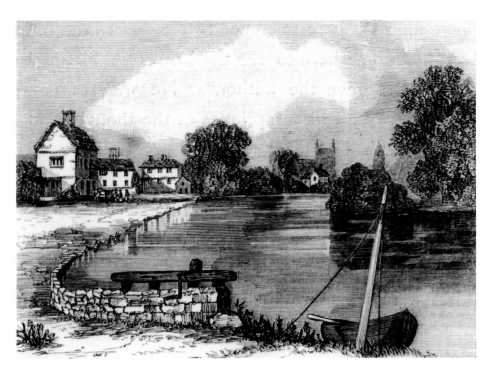

An Eighteenth-Century View

This engraving shows a much earlier scene, with the Offley Arms as a landmark along an otherwise undeveloped Poolside. Except for the Offley Arms, this would have been similar to the scene that greeted the second Sir John Offley and his friend and fellow angler, Izaak Walton, on one of their fishing expeditions in the 1650s.

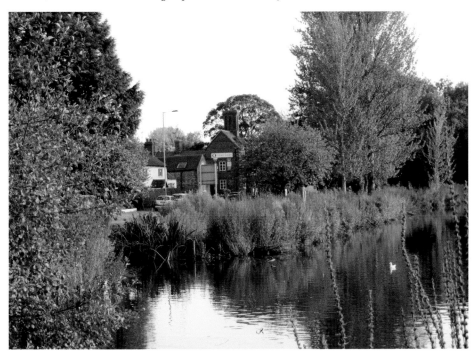

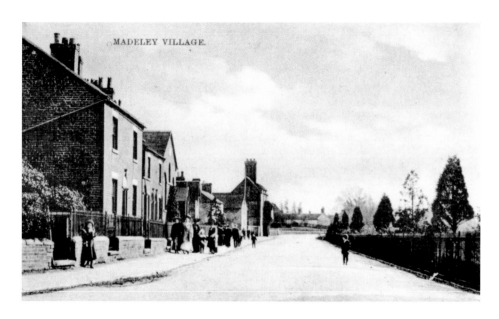

Poolside

Many of the buildings along this side of the Pool have survived with little change. In the older picture people are leaving the chapel dressed in their Sunday best. The chapel (in the inset) was a Primitive Methodist chapel. Primitive Methodism was strong in North Staffordshire and Madeley is only a few miles from Mow Cop where this form of worship was first preached. This chapel was 'very much a miners' church. Of the 107 fathers who had children baptised at the chapel between 1856 and 1932, 70 were miners' (J. Kennedy, p. 68). The front part of the chapel has been converted into a meeting room and café for the local Community Association and a new chapel area, constructed at the rear of the building, was dedicated in 1996

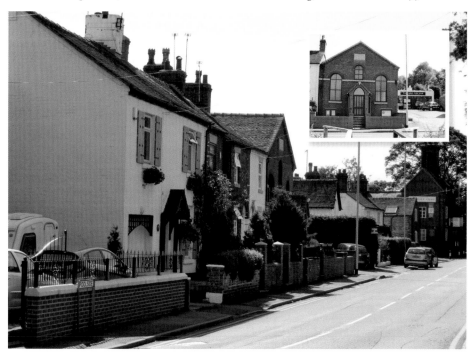

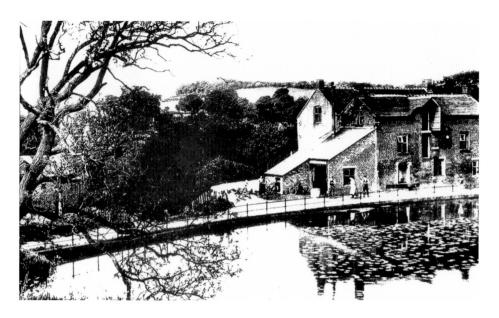

Madeley Mill

The Pool was formed to provide power for the water wheel machinery of the corn mill at its northern end. In the early 1930s, the corn mill became a cheese factory. Cheese making, traditionally a farmhouse industry, had a long history in the Madeley area. However, by the 1930s it was becoming a factory industry. It was in this period that the mill became a cheese factory. But, in 1970, the Madeley factory closed and for a time the mill, like the Pool, seemed in danger of disappearing. It survived in its present, altered form, by being converted into private residences. According to local people, 'the building is not very like the old mill but, from a scenic point of view, it satisfies the eye' (*Madeley in Living Memory*, p. 42).

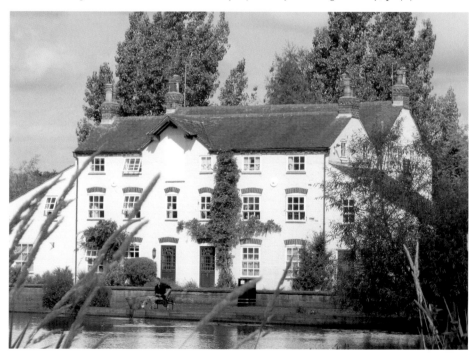

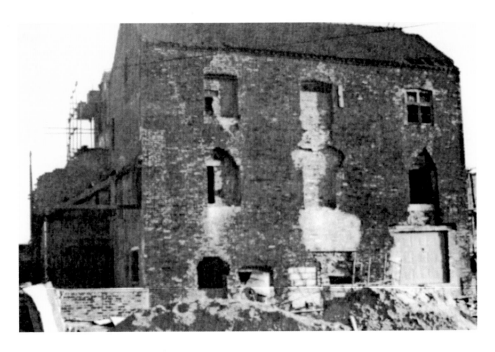

The Mill Under Reconstruction
This picture indicates the scale of the reconstruction of the mill in the late 1980s. The present view of the rear of the building makes a sharp contrast. The area behind the mill is now a pleasant residential area.

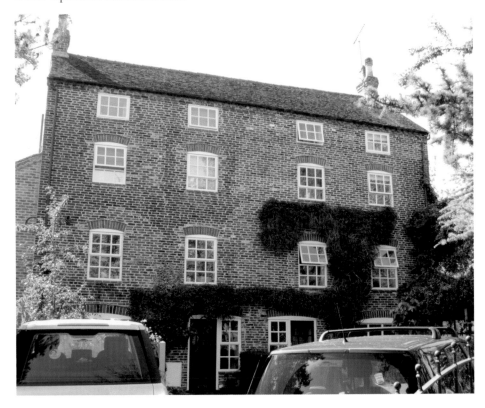

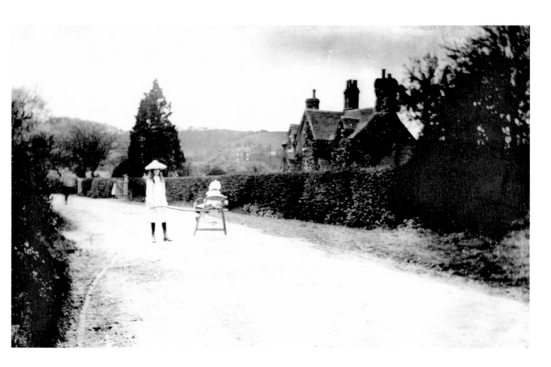

Moss Lane

Before the development of the Moss estate, Moss Lane was a quiet, narrow road that led down to the main railway line – quiet enough for the children to pose in the middle of the lane. The open view to the left of the house, with Moor Hall Farm in the distance, has disappeared. The house, with its Crewe estate crest, remains. A doctors' surgery and a housing development have been built in this area. As a result, this road is now a much busier thoroughfare.

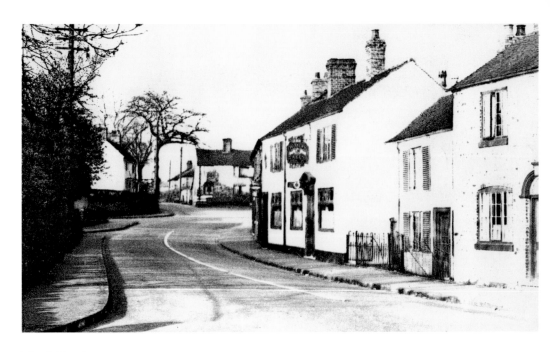

The Bridge Inn

This corner remains a busy area in the centre of the village, just beyond the Pool. Although the uses of the buildings on the right have changed, the buildings themselves are still recognisable in the modern picture. The Bridge Inn is now an Indian restaurant and several of the shops beyond the restaurant remain in use. The building in the central background of the old photograph was the Greyhound Inn.

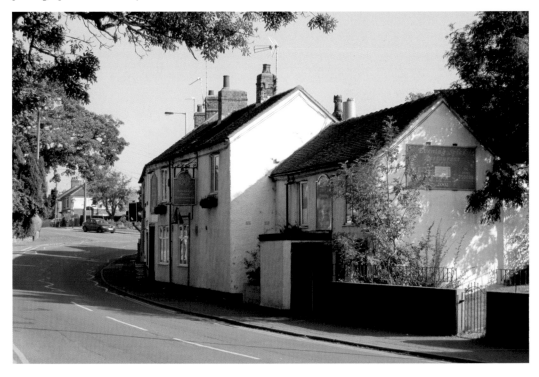

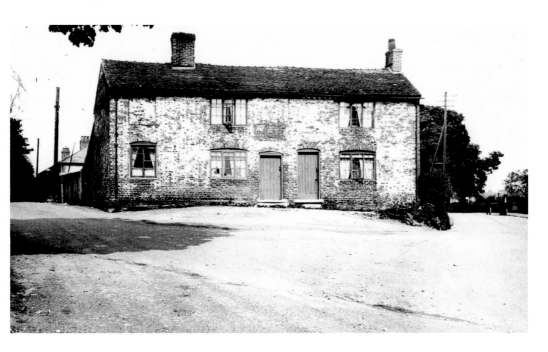

The Greyhound Inn

The old picture of the Greyhound was probably taken about 1930. By this time, the inn had been divided into cottages. It stood at the junction of the main road through the village and, to its left, New Road. All trace of this building has gone and the road junction has been widened.

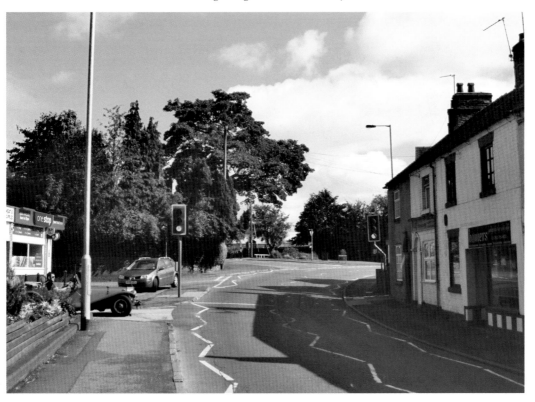

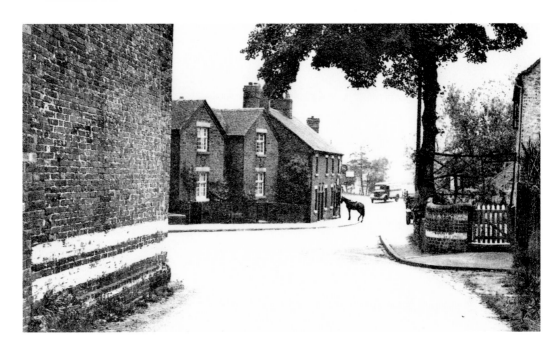

From the Greyhound

This view back towards the former Bridge Inn is similar in both the old and new photographs. The Greyhound building (immediate left) has gone and it is now unlikely that a horse would be tethered outside the shop (a bookmaker's at that time). However, the cottage on the right, which at one time was occupied by the Midland Bank, and the house on the left, complete with Crewe estate crest, are both still easily recognisable.

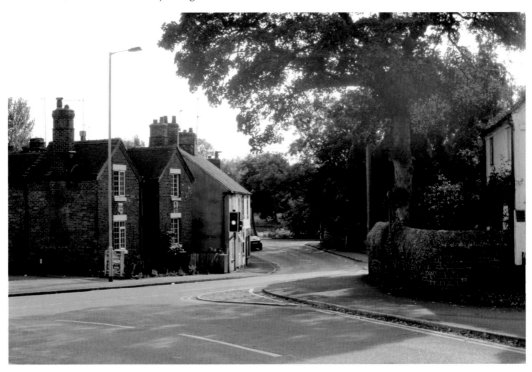

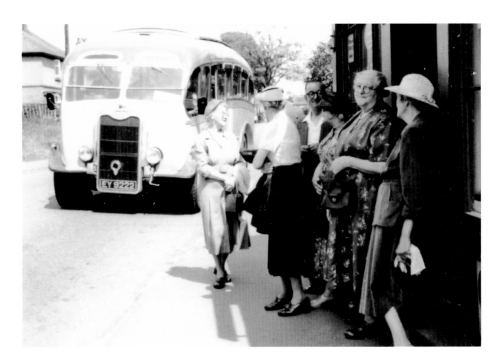

Percy Whalley's Shop

The house with the Crewe crest, shown in the present-day photograph, indicates the original line of the buildings on Greyhound corner. One of these was Percy Whalley's grocery shop, pictured here. The ladies are waiting for the approaching bus to take them on an outing. The date is probably post-1945. In the 1950s these buildings were demolished and the present shops and residences, known as Greyhound Court, were built in their place.

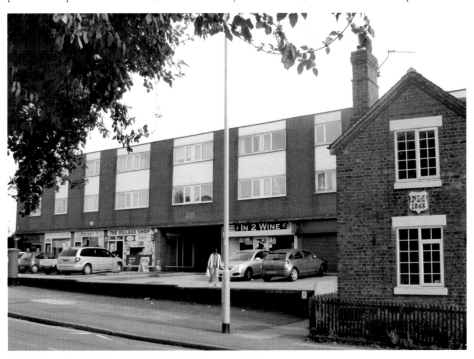

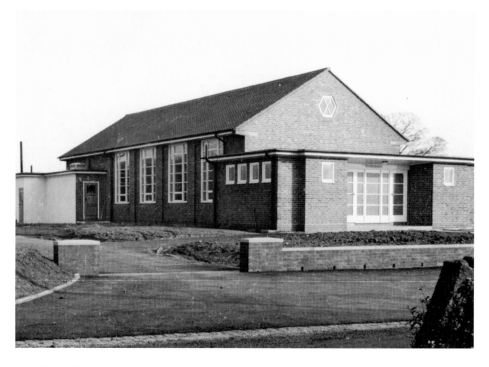

Madeley Village Hall

The village hall, pictured in the older photograph, has, very recently, been replaced by the much grander complex shown here. It was opened in June 2011 and provides a whole range of facilities for the Madeley community. There is a large hall for functions, shown on the right, and the buildings are eco-friendly. The apartments, part of the complex and to the left of the picture, mark the site of the old village hall. The hall in the older picture had in turn replaced another one, situated behind the Offley Arms.

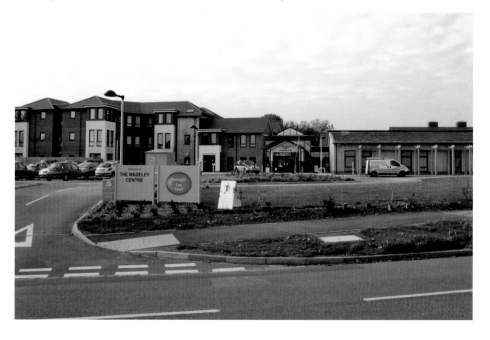

1920s Housing

Back on the main road, leaving Greyhound corner, the houses on the left were built in the 1920s. The present view shows little change on that side of the road other than the walls that have replaced former hedges. The road has been widened to cope with modern traffic. The buildings on the immediate right remain unchanged, but further on the road opens out at the entrance to the secondary school, built in the 1950s.

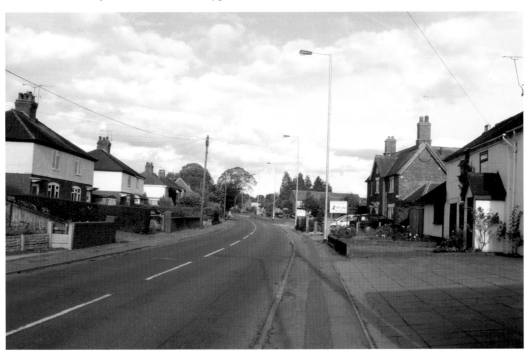

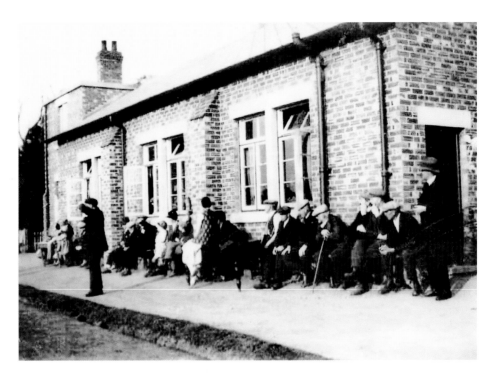

The Working Men's Club

In the older picture, a very attentive audience follows a bowls match at the old Madeley Working Men's Club. The old buildings have now been demolished and the club moved to new premises to the rear of a housing development. The new building is shown in the modern picture, with the bowling green re-sited.

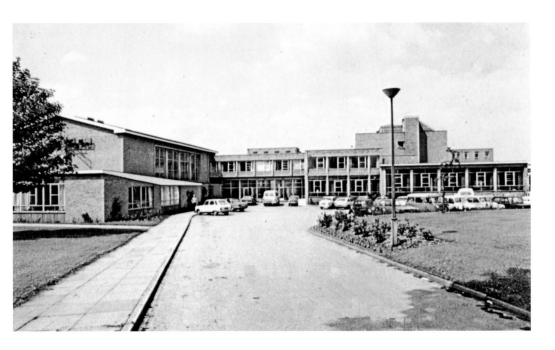

Madeley College of Education

Madeley College of Education began life as the County of Stafford Teacher Training College in 1949. It was housed in largely prefabricated buildings at Nelson Hall, near Eccleshall. In 1961, building of a new, purpose-built college began at Madeley. It was sited on the lower slopes of the parkland formerly belonging to the nineteenth-century Madeley Manor. However, the life of the new college was short as Government policy on teacher training changed and, by 1982, the college had closed. As the new picture shows, the area has become a large housing estate.

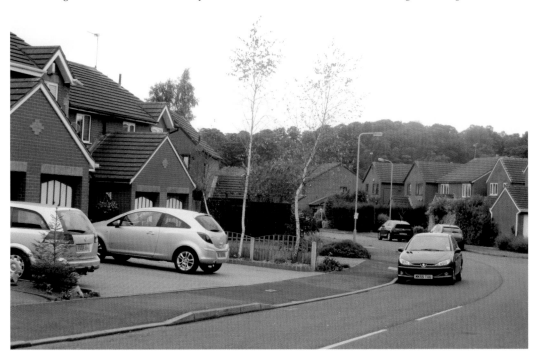

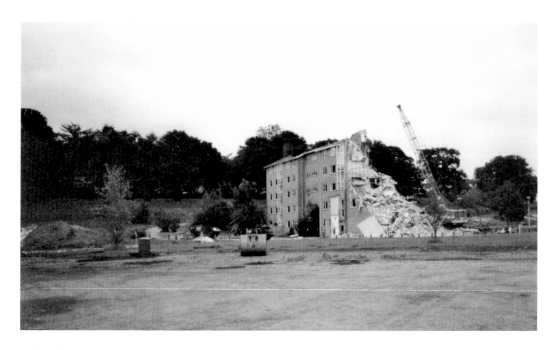

Halls of Residence, Madeley College

The Halls of Residence provided accommodation for students and some staff. There were 1,200 students in residence here in 1970 in addition to those still housed at Nelson Hall. It was hoped that these halls of residence might survive the closure of the college but, as these photographs show, they were demolished and houses were built in their place on what was called College Gardens estate.

Newcastle Road Towards Village

Looking back to the centre of Madeley, the main road that passes the former college site is now a busy thoroughfare. The modern photograph shows the road, largely built up on both sides. There are pre-war houses on the left and the modern estate, built in the grounds of the now demolished college, on the right. The old photograph, in contrast, shows a quiet rural scene, probably in the early 1930s.

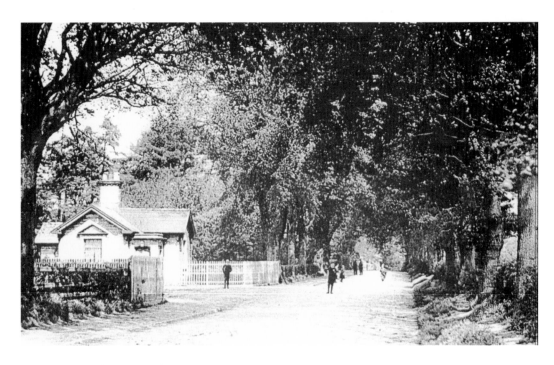

Newcastle Road Towards the M6

Looking in the opposite direction to the previous photographs, the old photograph repeats the same theme of quiet rural life. On the left, the white building is the East Lodge of Madeley Manor, which is situated high above the lodge. The modern picture reveals a wider, faster road but less built up than was seen along the road in the direction of the village centre.

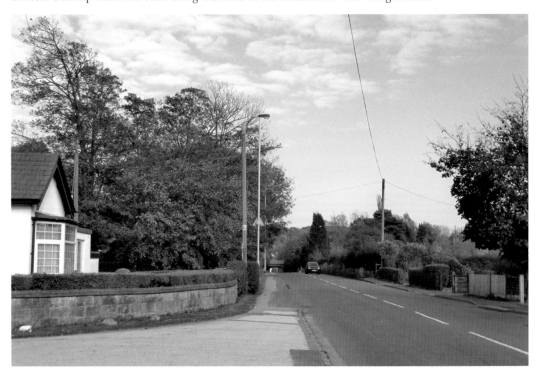

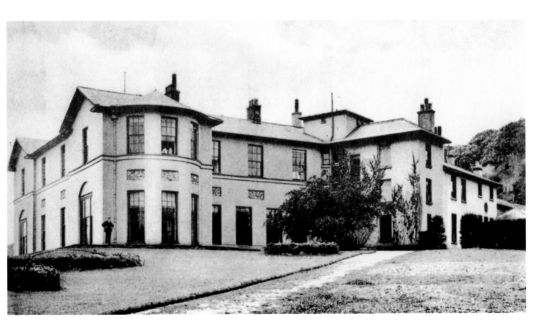

Madeley Manor

Madeley Manor is a fine Regency house. It was built in the 1820s on the site of an older house: 'over £12000 was used to extend an existing timber framed yeoman's house to create a Regency gentleman's house of advanced design' (J. M. & L. Williams, p. 1). It is set in parkland on the slopes of Bryn Wood and overlooks a lake. It was a Crewe family residence, but only second to the much grander Crewe Hall. At first, it was occupied by the Cunliffe-Offley branch of the family. It was Mrs Cunliffe-Offley who was commemorated in Manor Road. Later the manor was leased out and finally sold in 1951. It is at present Madeley Manor Care Home.

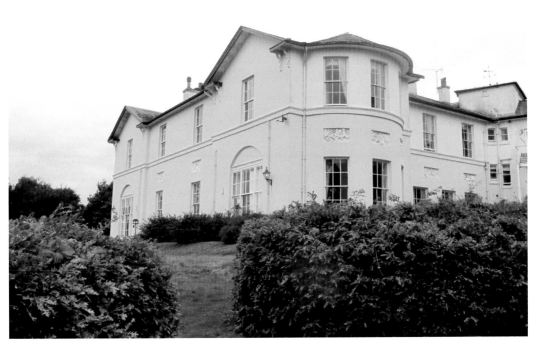

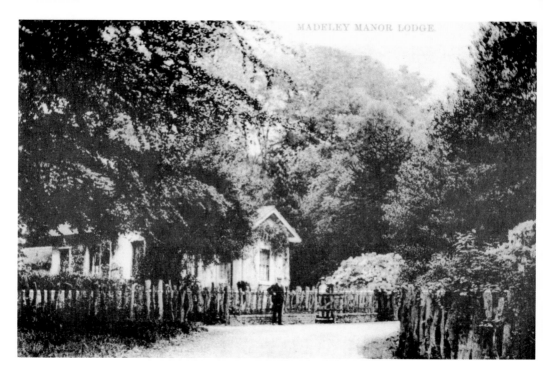

West Lodge

The present appearance of this modern-looking bungalow is deceptive. Attractively set in Bryn Wood, it is in fact the West Lodge of Madeley Manor. Only on closer examination does its similarity to the East Lodge emerge.

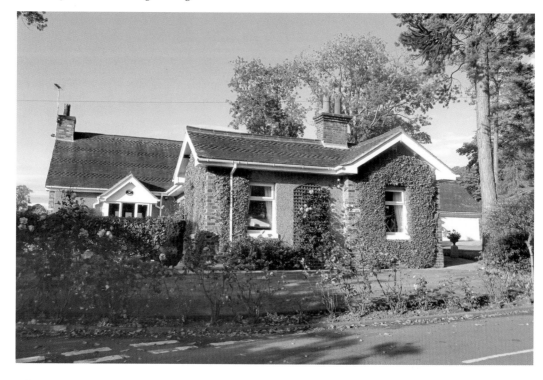

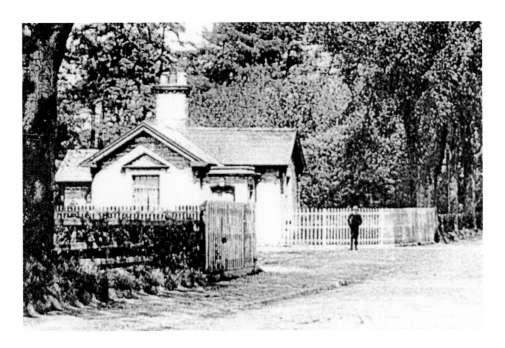

East Lodge

The East Lodge of Madeley Manor, now a private residence, is situated on the main Newcastle Road at the bottom of the parkland leading to the manor itself on higher ground. As the modern picture shows, it still retains much of its early appearance. The drive to the left of the lodge led to a tree-lined carriageway to the manor. The parkland that swept up towards the manor from this lodge was used for an annual fête in the 1880s. The famous tight-rope walker, Blondin, appeared three times before large crowds, many travelling to Madeley from the Potteries. At its peak in 1889, the fête raised £800, a very large sum at that time.

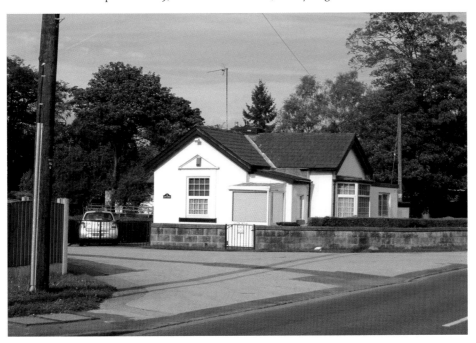

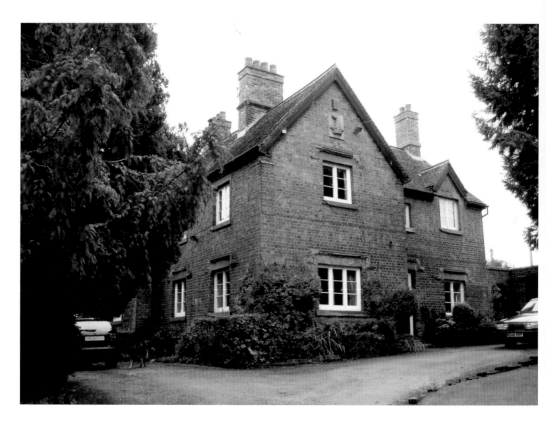

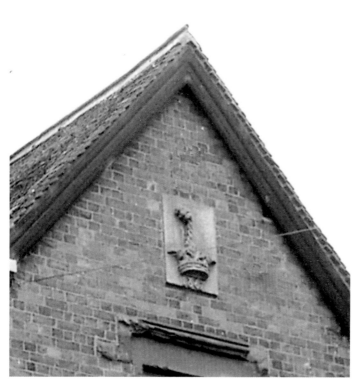

Hazeley House
This substantial house was built during Hungerford Crewe's time for the colliery manager at the Leycett coal mine. The Crewe estate owned the land at Leycett in the north of the parish and leased out the land to coal mining companies. The Crewe estate crest still appears on a number of houses in the parish, In this close-up picture, the crest is clearly shown above the date of the property.

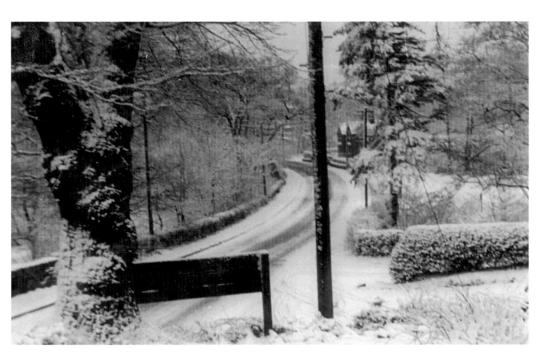

Before and After the M6

The M6 traversed the parish of Madeley in 1962. Here it crosses main road from the village, leading to a realignment of that road. Here the winter scene shows the road at Fernyhough Bank, just beyond Hazeley House, before the motorway bridge. In the recent photograph the line of that road has been changed. The cottages, shown on the right in the older picture, are still there but no longer in sight.

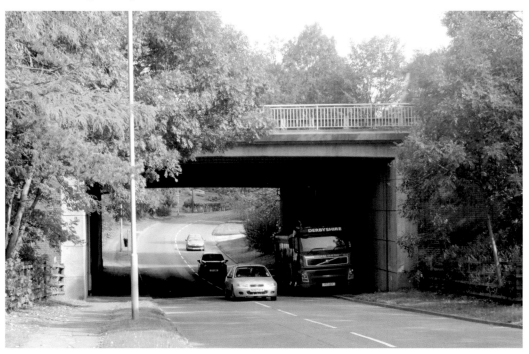

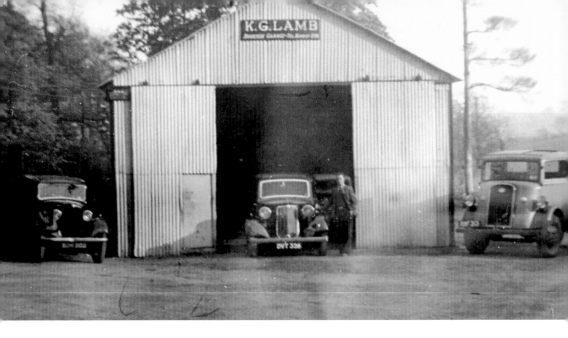

Lamb's Garage

This garage was a casualty of the M6 motorway, which crosses the road from the village at this point. The garage site is shown on the left side of the modern picture, now the blank concrete bridge support.

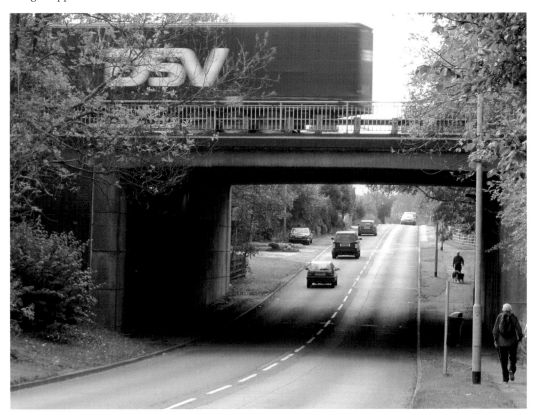

The Meadows Primary School

As the architecture of the older building suggests, it served as a church as well as a school. It was one of three mission churches built, with Hungerford Crewe's support, at Madeley Heath, Onneley and Leycett. The Meadows was also used as a day school and Sunday School. Eventually the building ceased to be used as a church and has continued to be a part of the Meadows County Primary School. A building to the right, just out of sight, was the head teacher's house.

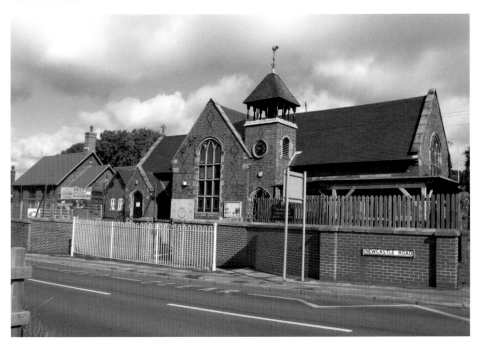

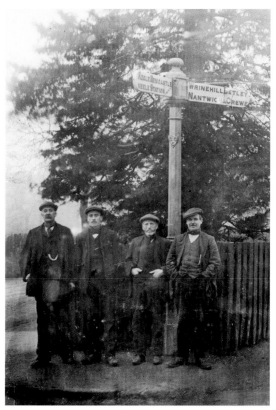

The War Memorial

The red sandstone memorial is a striking reminder of the dead of two world wars. It records the deaths of forty-four men in the First World War and fifteen in the Second World War. As the older picture shows, this site, at the junction of two main roads, was a popular meeting place before the memorial was built.

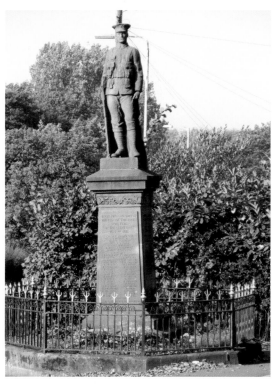

The Road Junction at the Memorial

The quiet rural scene in the older picture has given way to a busy traffic junction in more modern times. Here, the main Newcastle–Nantwich Road meets the road from Woore, which runs through the village. The fingerpost has gone and it is the memorial that dominates the scene. The modern picture also shows Meadows School and the former schoolhouse.

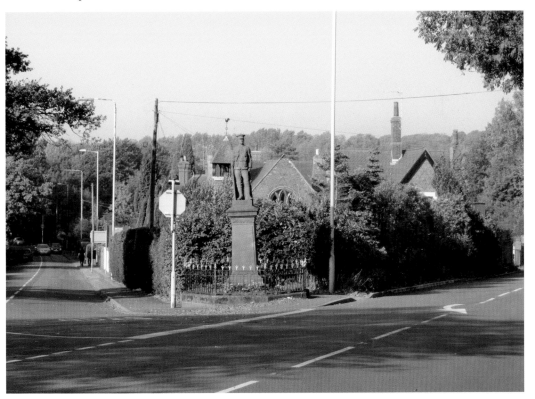

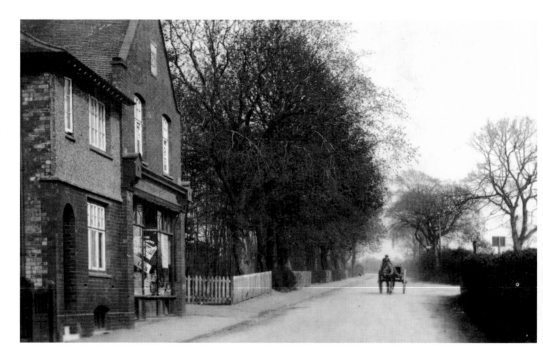

The Madeley Heath Co-operative Shop

The Co-operative shop was sited just past the memorial, on the main Newcastle–Nantwich road. It remained open until around 1970; the last shop left in what was once a busy area. A considerable number of new houses were built in this area but, as local people comment, 'most of the people on the new Hillwood estate were car owners who preferred to shop in town' (*Madeley in Living Memory*, p. 63). The house to the left is still occupied.

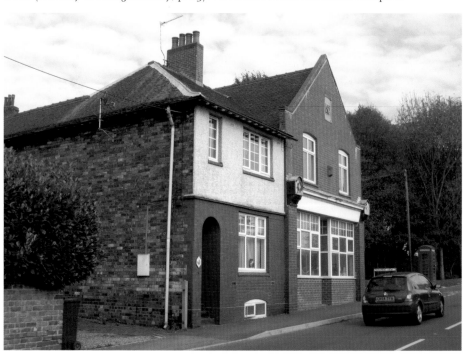

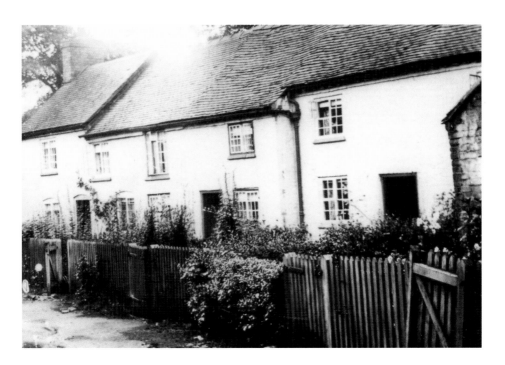

Fullers' Cottages

Just along the road from the Co-op, in the area called Swan Bank, were the cottages depicted in the old photograph. They were originally thatched and may have been fullers' cottages, the vestige of a much earlier woollen industry in the area. Fulling is mentioned in Robert Nicholls's *Short History of Madeley*, but no mill site has been found. The cottages have been replaced by the modern property.

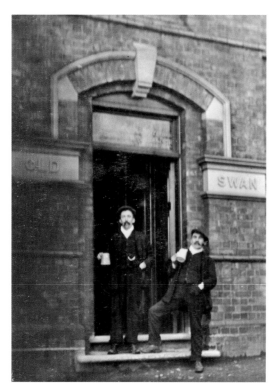

The Old Swan

The picture on the left shows two happy customers emerging from the Old Swan early in the twentieth century. The public house continues in business without much change to its outward appearance. The building certainly predates the twentieth century: there is a reference to the Old Swan being used for a celebration in 1865. After a wedding of a member of the Stanier family (ironmasters in a nearby locality and then tenants at Madeley Manor), a dinner was held for the family's employees at the Old Swan (J. M. & L. Williams, p. 34). Some of the brickwork of the building suggests a date earlier than the nineteenth century.

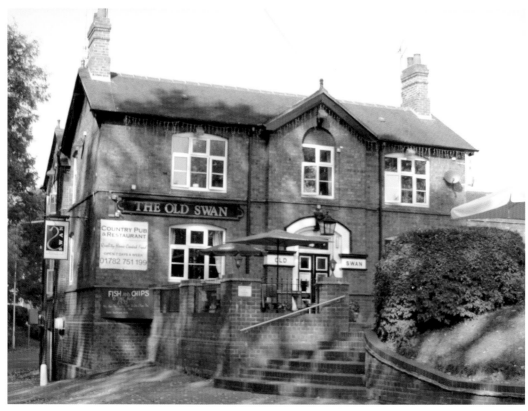

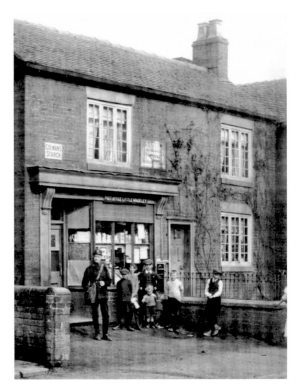

Swan Bank Post Office

Just past the Old Swan was Swan Bank post office and shop, here shown in the interwar period. A postman in his uniform, along with a group of children, has been persuaded to add a human touch to the picture. A modern house has replaced the post office.

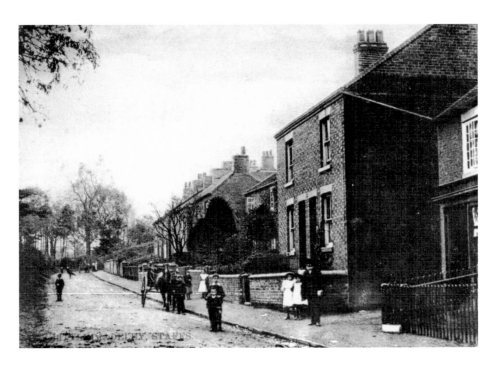

Swan Bank

The old photograph, taken prior to 1914, shows Swan Bank with the post office on the right, two other houses and a double row of houses to the left. The main road to Betley and Nantwich appears in a very rough condition. The scene has now changed considerably. Modern houses replace all but the back row of those shown in the centre of the old picture. The front row was demolished when road widening was being considered. Once again the photographer of the earlier picture has gathered a good collection of children to pose for him, plus the horse and trap.

The Old Wharf

Along the Nantwich road, just after it is now crossed by the M6, is the site of an early wharf for the sale and distribution of coal from Leycett. It was brought by tramway through Walton's Wood along a line that can still be followed in parts. Coal had been mined at Leycett well before the nineteenth century: 'in 1637 Sir John Offley leased "all his mine at Leycett" to one Ralph Vernon' (J. Kennedy, p. 56). This early wharf was at the position shown by the cottage in the old picture. These buildings have now gone as the modern picture of the same shows. This wharf was replaced by a new one at Madeley Heath in the nineteenth century.

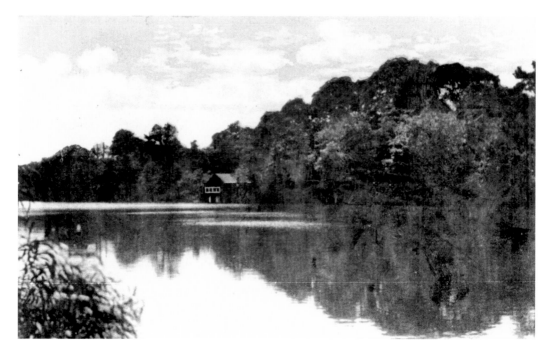

Manor Lake and Boathouse

This scene is almost directly opposite the Old Wharf site. The lake and its boathouse were part of the Madeley Manor grounds that were laid out in the 1820s. It provided the manor with an attractive view and leisure amenity. It is now privately owned and used by the local angling club.

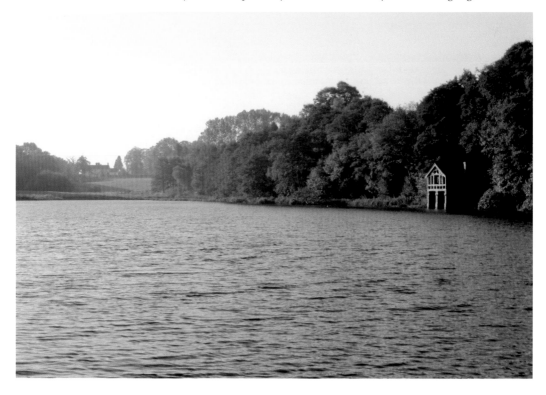

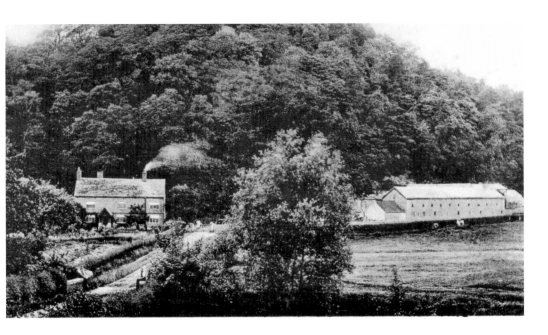

Heighley Castle

A few fragments of the stone walls of Heighley Castle remain in its hilltop position on the left of these pictures. It was the more permanent castle built by the Audley family when they left the wooden structure in the village of Audley, a short distance to the north. The demolition of Heighley castle was ordered by the Parliamentarians in 1644 to prevent its use by the Royalists. The scene depicted in the older picture (around 1910), with the focus on Heighley Castle farm, has hardly changed in the intervening century.

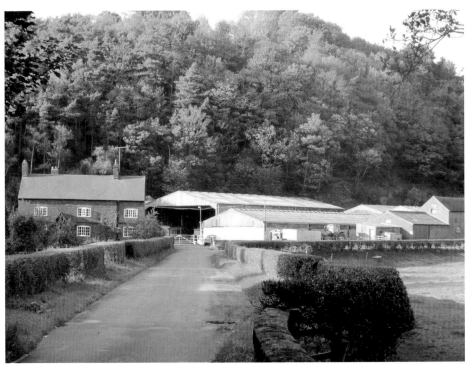

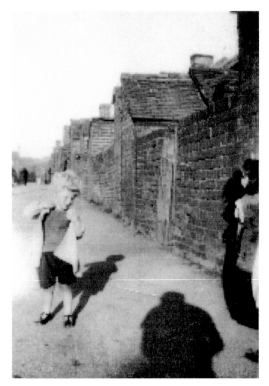

Longrow (Now Renamed Heathrow)

Returning to Madeley Heath, the traveller arrives in what appears, in the modern picture, as a quiet residential area. Although that is now the case, this was the scene of considerable industrial activity for over 100 years until the 1950s. In the old photograph, the little boy stands in front of housing that would have been occupied by workers in the brick and tile industry. Opposite these houses was a deep marl pit for the extraction of the clay needed for that industry. The pit has been filled in and turned into a pleasant play area.

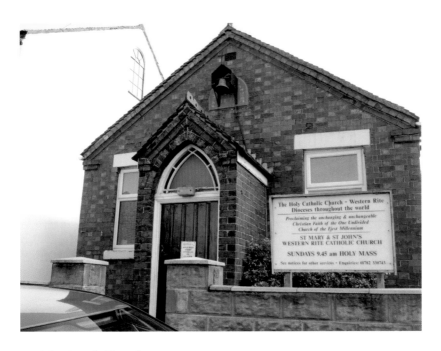

Madeley Heath Chapel

This was another Primitive Methodist Chapel in the parish. The date of its building – 1897 – is carved on the stone above the door. Like the Poolside chapel, it was a miners' chapel, and eight of the thirteen trustees were miners. Numbers in the congregation dropped over the years and in 1992 it was sold to its present occupants, the Holy Catholic Church – Western Rite, and renamed St Mary and St John's. The exterior of the chapel has not changed but its interior, shown in the second picture, reflects the different form of worship now practised.

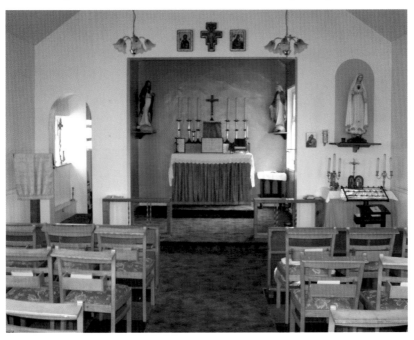

Wharf Terrace

Turning left from Heathrow, this side of Wharf Terrace retains the cottages once mainly occupied by workers in the local industries. At the end of the road, visible in the recent picture, is a building that was used for the drying of bricks. As well as the brick and tile works, there was an iron works behind the terrace.

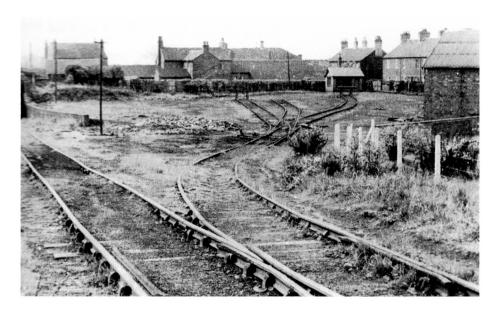

Wharf Terrace: the Landsale Yard

The older picture shows the Wharf Terrace cottages on the right. They look onto the wharf, or landsale yard. Here the coal from Leycett was brought by rail for sale to the local industries, and local inhabitants. Trucks could unload coal and pick up bricks or tiles. The lines going into the yard connected to the line running to the sidings at Madeley Station. This busy scene has disappeared completely, to be replaced by the houses and gardens shown below.

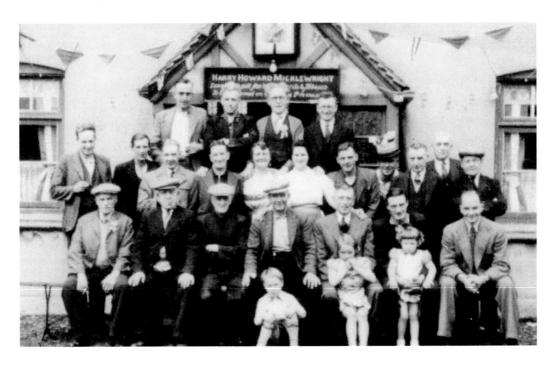

The Crewe Arms

The Crewe Arms backs on the site of the coal wharf, and along its right side the Madeley Branch Railway ran from Leycett to Madeley Station. The group is celebrating outside the Crewe Arms at the time of the Coronation in 1953. The recent picture shows some changes to the frontage of the pub. However, it is the area around it that has changed most dramatically, as the previous photographs have indicated.

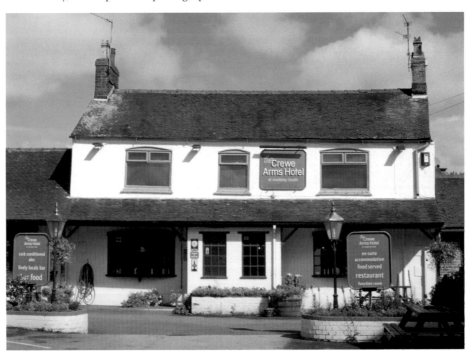

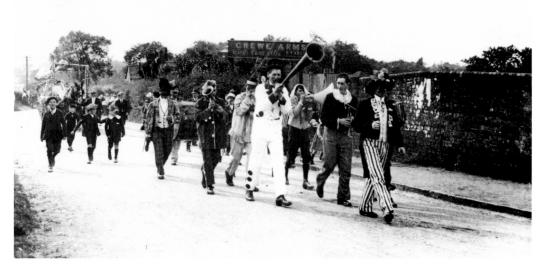

A Parade Past the Crewe Arms

This jolly group of revellers is parading along the main Newcastle–Nantwich road. The sign for the Crewe Arms is behind them and they are crossing a bridge, the wall of which is shown clearly behind the leaders. The new picture captures the same scene. The road is wider and busier, the sign to the Crewe Arms has changed –and the wall of the bridge has virtually disappeared. The next two pictures supply an explanation.

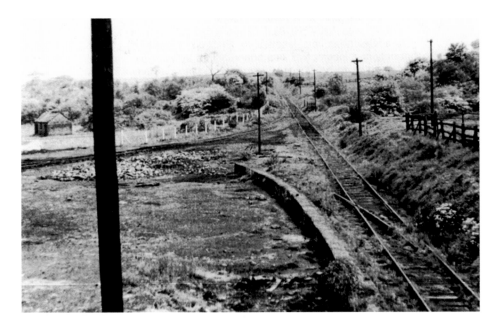

Madeley Branch Line

The low brickwork in front of the garden in the new photograph is the remnant of a bridge. Beneath the bridge ran the railway line that linked the colliery at Leycett with the main line at Madeley Station. This line is shown in the old picture, going from this area towards Leycett. Not only has the bridge disappeared but the cutting beneath it has been completely filled in. This is shown in the modern photograph by the garden and house behind the traces of the wall. The line, with its branch into the wharf behind the Crewe Arms, was of immense importance to the development of Leycett.

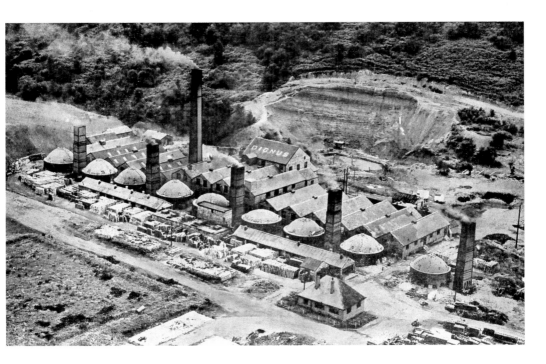

Dignus Tileries, Honeywall Lane

On the opposite side of the main road to the Crewe Arms is Ridgewill Road. A walk along this road leads to the large industrial site of Marley Eternit, shown in the modern picture. This site carries on the tradition of tile making in the Madeley Heath area. A deviation from Ridgewill Road, down Honeywall Lane, takes the traveller to the site of the old Dignus tileries, now defunct. The remarkable older photograph shows these extensive works.

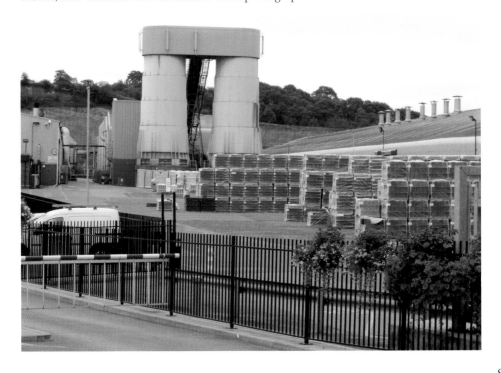

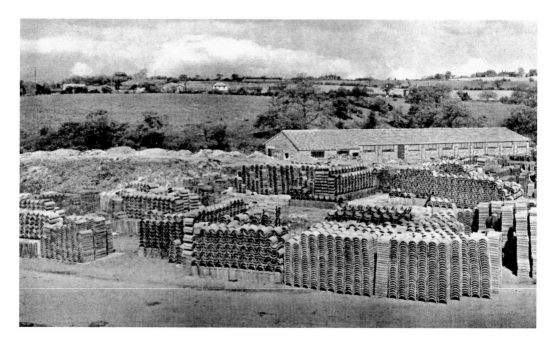

Dignus Tileries and the POW Camp

The old photograph shows the prodigious output of the Dignus works awaiting transport. Below, the modern picture shows the abandoned site, now the property of a timber merchant. There is another interesting aspect to this site. During the Second World War, it was used as an army camp and a prisoner of war camp. The long building in the picture was used to house the prisoners.

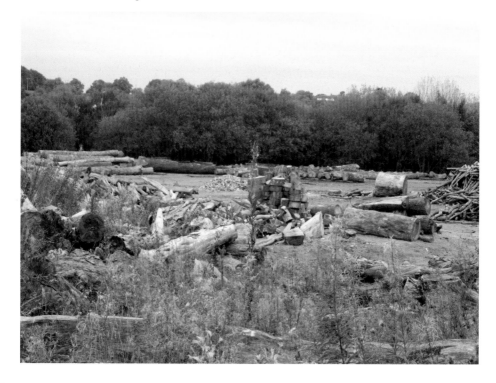

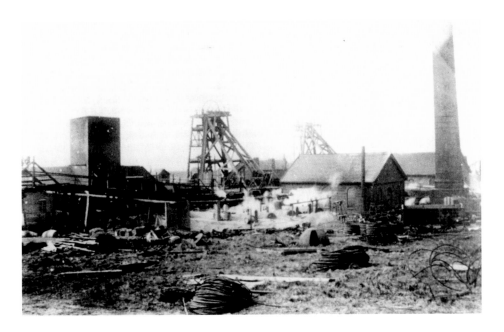

The Miners' Memorial, Leycett Lane

The approach to Leycett is reached at Leycett Lane. The entry to Leycett Lane is marked by a memorial to the miners who lost their lives in the mines of the village of Leycett. The deep mining of coal developed from the 1830s on land leased by Crewe estate. An early lessee was Thomas Firmstone in 1838, a man who was to play a vital role in linking the pits to the railway system. Later Thomas Harrison was a prominent figure who, with other directors, formed the Crewe Coal & Iron Company (1866). The Harrison and Woodburn shafts are pictured here. They were a short distance from the two other main shafts, known as Bang Up and Fair Lady.

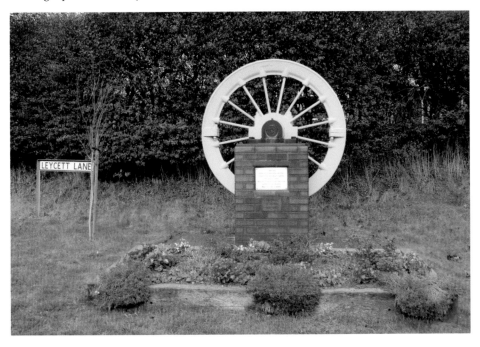

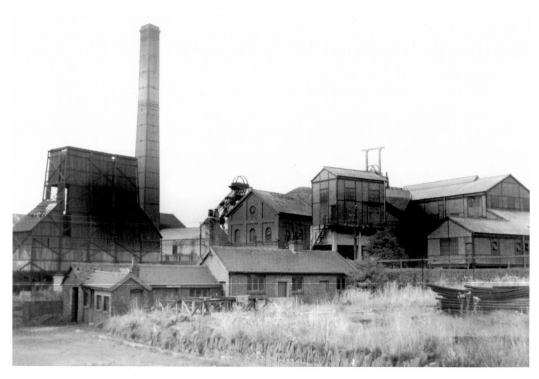

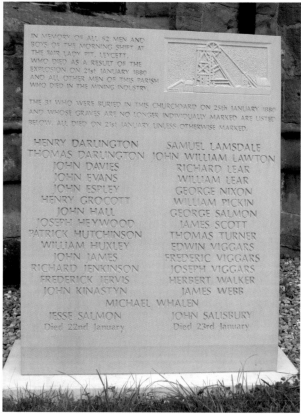

IN MEMORY OF ALL 62 MEN AND
BOYS OF THE MORNING SHIFT AT
THE FAIR LADY PIT, LEYCETT,
WHO DIED AS A RESULT OF THE
EXPLOSION ON 21st JANUARY 1880
AND ALL OTHER MEN OF THIS PARISH
WHO DIED IN THE MINING INDUSTRY.

THE 31 WHO WERE BURIED IN THIS CHURCHYARD ON 25th JANUARY 1880
AND WHOSE GRAVES ARE NO LONGER INDIVIDUALLY MARKED ARE LISTED
BELOW. ALL DIED ON 21st JANUARY UNLESS OTHERWISE MARKED.

HENRY DARLINGTON	SAMUEL LAMSDALE
THOMAS DARLINGTON	JOHN WILLIAM LAWTON
JOHN DAVIES	RICHARD LEAR
JOHN EVANS	WILLIAM LEAR
JOHN ESPLEY	GEORGE NIXON
HENRY GROCOTT	WILLIAM PICKIN
JOHN HALL	GEORGE SALMON
JOSEPH HEYWOOD	JAMES SCOTT
PATRICK HUTCHINSON	THOMAS TURNER
WILLIAM HUXLEY	EDWIN VIGGARS
JOHN JAMES	FREDERIC VIGGARS
RICHARD JENKINSON	JOSEPH VIGGARS
FREDERICK JERVIS	HERBERT WALKER
JOHN KINASTYN	JAMES WEBB

MICHAEL WHALEN

JESSE SALMON JOHN SALISBURY
Died 22nd January Died 23rd January

The Fair Lady Pit Disaster (1880)
The worst mining disaster in Leycett occurred in January 1880. Sixty-two men died after an explosion and fire in the Fair Lady shaft. It was not the first, or last, disaster in that same shaft: eight died in 1879, six in 1883 and eight in 1897. Thirty-one of the victims in 1880 were buried in unmarked graves in Madeley churchyard. It is appropriate that the new memorial (2011) in the modern picture has been placed next to the entrance to the church.

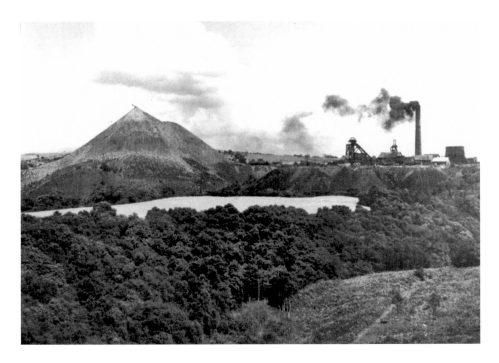

Leycett Colliery – Before and After

These pictures show the industrial landscape that Leycett's inhabitants saw at close quarters every day, and the rural aspect of the site today. The mines were in their day very productive: Fair Lady was raising 650 tons in an eight-hour shift in 1895 (A. Baker, p. 320). In 1929, 1,230 men were employed underground in the Leycett collieries and 300 on the surface. However, the number employed was down to 839 on nationalisation in 1947, and 405 when coal mining ceased in 1957.

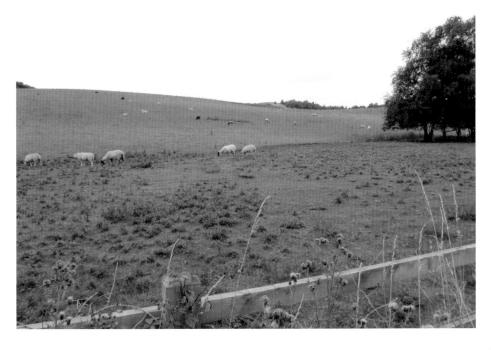

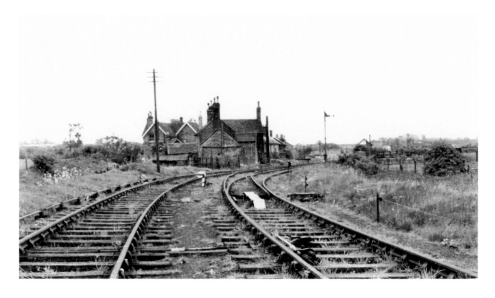

Leycett Station

Leycett's rail links were essential for the developmet of large-scale coal production in the area. Coal could be delivered to the brick and tile makers at Madeley Heath. Wider national markets could be served by linking Leycett to the main line at Madeley Station. The older photograph shows the North Staffordshire Railway (NSR) line approaching Leycett Station from the north. The line, opened in 1870, ran between Alsager and Keele and served the mines of the Audley area and Leycett. Of the station buildings shown in the old picture, only two buildings remain. One is the stationmaster's house, the rear of which is shown on the left in the older photograph. The present-day photograph shows the well-preserved house, now a private residence.

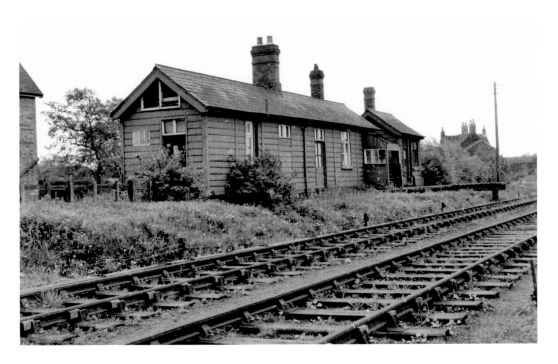

The Waiting Room

The wooden buildings in this photograph (also just visible in the previous one of the station) are the waiting room and the porters' room at Leycett Station. The buildings, now used as a garage, are the only surviving parts of the station. The new picture shows the still recognisable end of the station building.

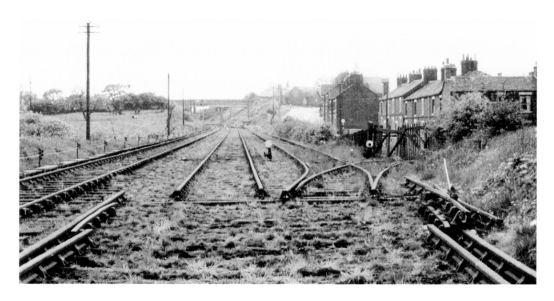

The NSR Audley Line

The view of the line was taken in the 1960s after traffic had finished. On the right a line branches off into the colliery yard. The photograph also shows some of the houses of Leycett village. At the top of the picture is the mission church .This view makes very clear the juxtaposition of the mine and the houses of the village. Nothing depicted here remains. The cutting has now been filled in and the land returned to fields.

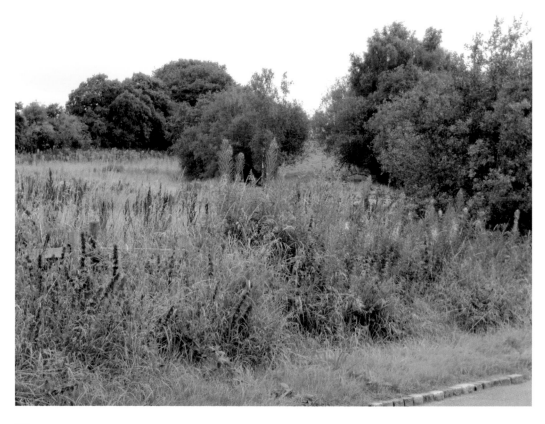

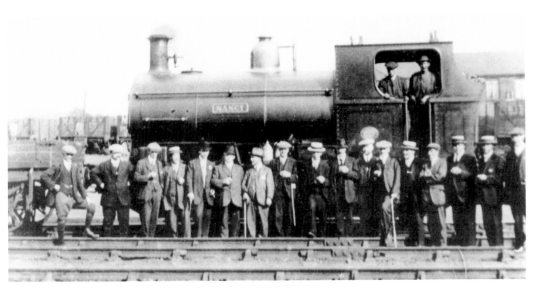

The Rail Link with Madeley

This gathering, probably of directors and officials of the Leycett colliery company, is at the sidings of Madeley Station – sidings that have now disappeared, as the modern photograph of the site shows. However, the older picture underlines the importance of the branch line in the development of coal mining at Leycett. Through the foresight of Thomas Firmstone in the 1830s, a standard gauge-branch line was built from Madeley to Madeley Heath and Leycett. 'Leycett was the first location in North Staffordshire to enjoy a standard gauge connection with the developing main-line railway, and the first to employ locomotives.' (Baker, p. 313).

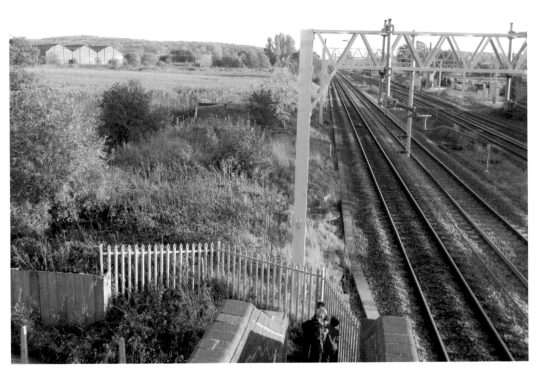

Leycett Village: the Main Street

Leycett was a planned pit village, with its houses and amenities sited next to the coal pits that were the reason for its existence. This mid-twentieth-century view shows the main street, with the school the most prominent building. The housing, some of which is further down the street, displayed the Crewe crest as this village was on Crewe Estate land. As the modern view shows, only the school and schoolhouse survive in any form at all.

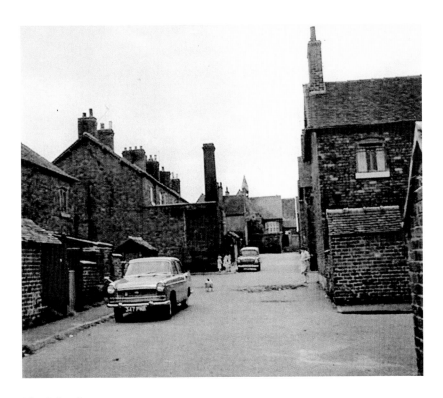

The School

As the modern photograph shows, the school building remains though in a dilapidated state. The back of the school is shown in the centre of the earlier picture. The much-altered schoolhouse is to the right of the school behind its modern brick wall. The school was opened in 1870 and closed just over 100 years later in 1972.

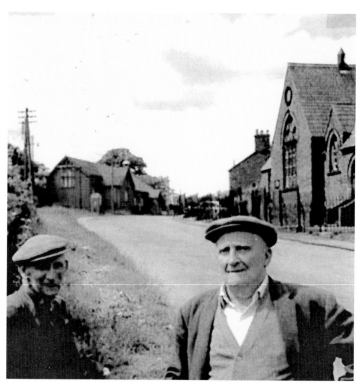

Church, School and Institute

Behind the two men in the foreground of this personal photograph, three important village buildings are shown at the top of the street. On the right is the school. On the left, at the top of the hill, is the church, and behind that was the Miners' Institute. Like the mission churches at Onneley and Madeley Heath, the Leycett church was built with the support of Hungerford Crewe. Today the site of these buildings, so influential in the life of the village, is the waste recycling area shown.

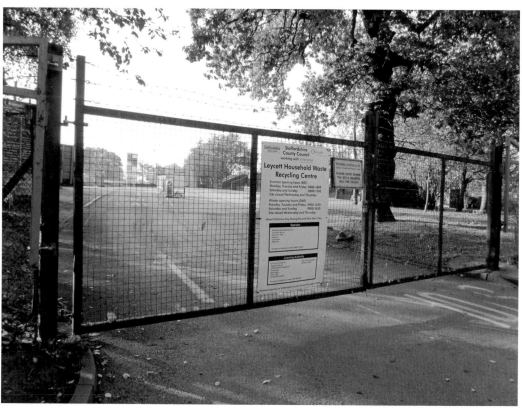

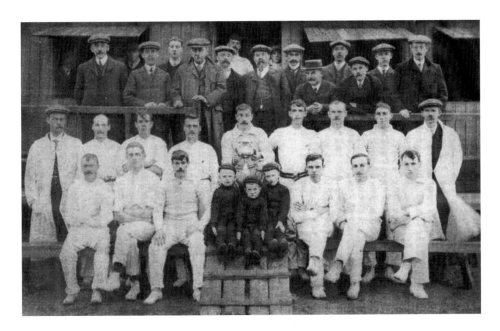

Leycett Cricket Club

Village cricket has survived long after the village itself has gone. Local league cricket is played behind Park Terrace, the only terrace of housing left in Leycett. The team in the old picture is the team of 100 years ago, but the club is older than that and was probably founded in the 1870s. The present team plays in the North Staffordshire & South Cheshire League. In the modern photograph, the last game of the 2011 season is played in front of their fine modern pavilion.

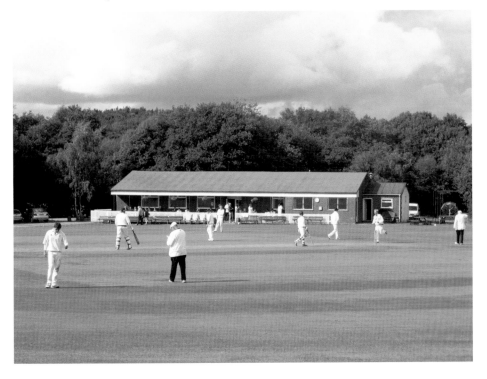

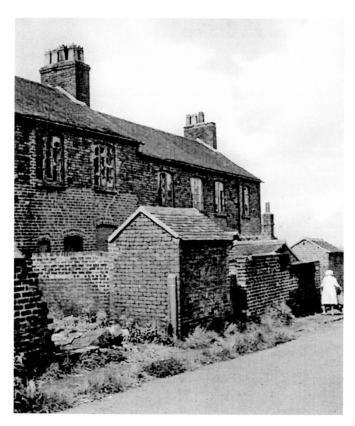

Housing in Leycett

Two-storey houses were arranged in a rectangle next to the main road through the village. There were three streets, rather unimaginatively named as Top Street, Middle Street and Bottom Street. The pit overshadowed the village and the steam engines ran along the railway at its edge. The conditions cannot have made for comfortable living. However, local people's memories speak of a tight-knit mining community and of regret at the village's demolition. When the older picture was taken, the process had begun. By the mid-1960s the demolition of the houses was well under way.

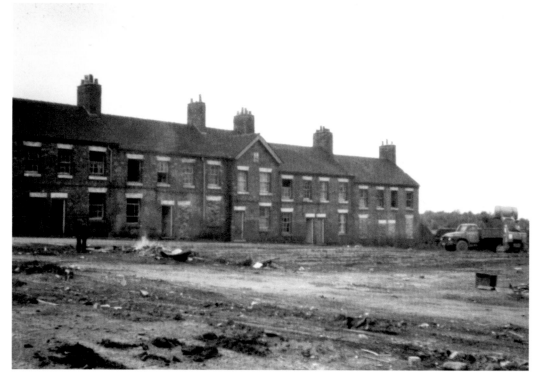

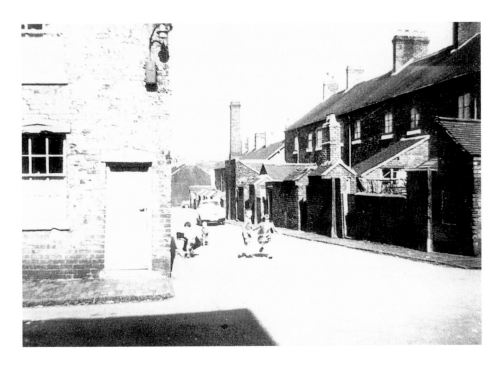

The Vanished Village

The older picture shows an everyday scene in the village, probably in the 1950s. Now, sheep graze peacefully where the three streets of houses once stood. The closure of the mines and the rail links led to many leaving the village for work elsewhere. What had been a vibrant mining community disappeared. Only the photographs and memories of local people remain to fulfil the important task of recording the life and work of this vanished village.

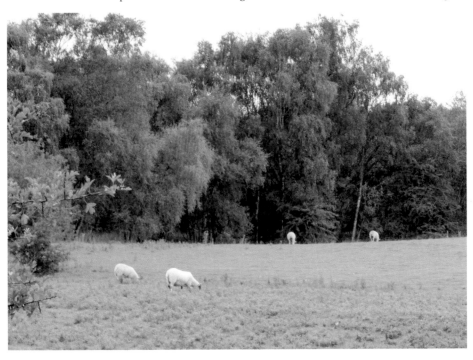

Acknowledgements

Absolutely essential for writing this book was someone who knew every inch of the area, who had enormous enthusiasm about its history and who had a fine collection of photographs – and in Terry Elkes I found that person. So, first of all, I must record my many thanks to him.

Then there were others who went out of their way to help on this project. Doreen Dracup and Peter opened the church and helped me access much information there. Andrew Finney helped me find some really useful photographs from his excellent website; some from the Ted Oxer Collection (The Old Swan, Town House, War Memorial Corner, Knightley, Monument Lodge) and one was his own (Dredging the Pool).

Mary Cooper and Duncan Williams were very helpful, as were the three ladies at the Poolside café, who, through the good offices of Alan Wilson, kindly lent me their collections of photographs of Madeley: Mary Blaise, Vera Davenport and Ricki Williams. Alf Brooks found some very useful pictures and shared some boyhood memories of Madeley. Michael Craghill was very informative about Onneley and its Community Centre. Jane Sheldon, Newcastle Borough Council, gave me some statistics on the parish. Then there were the complete strangers I met as I went around the village and who gave me useful information and encouragement.

All my efforts might have been in vain without the computer skills and enormous patience of Linda Forrester. The book would never have been completed without Jane's camera skills and her ability to put up with the demands of book writing. Sarah, Ruth, Katie and Emma all gave valuable help.

The following books were very useful: J. Kennedy, *Madeley – A History of a Staffordshire Parish* (1970) is a clearly written history, full of insights. Vicky Moss, *Madeley in Living Memory* (2000) has a lot of information from Madeley people. There were also: A. Treherne and G. Lancaster, *Old Madeley – An Album of Photographs* (2003); B. & D. Morris, A. & J. Priestly, R. Simmons & E. Watkin, Keele, Madeley and Whitmore: old postcard (1990); R. Nicholls, Madeley, Stafffordshire (1935); J. M. & L. Williams, *The New Madeley Manor House* (1999). There is also an entry for Madeley in N. Pevsner, Staffordshire (*The Buildings of England*, 1974). D. M. Palliser, *The Staffordshire Landscape* (1976). On railways and collieries, there are A. C. Baker, *Madeley and Leycett Collieries* (Industrial Railway Society, No. 161) & his *Illustrated History of Stoke and North Staffordshire's Railways* (Irwell 2000); C. R. Lester, *The Stoke to Market Drayton Line* (Oakwood Press, 2001).